Tea Bag Folding

Janet Wilson and Tiny van der Plas

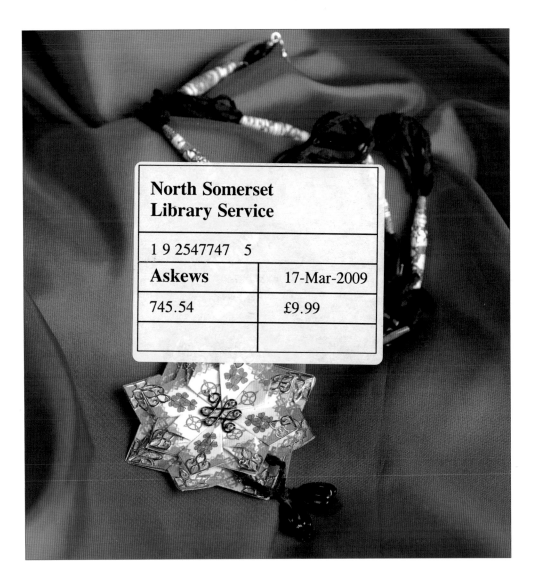

SEARCH PRESS

First published in Great Britain 2008

Search Press Limited
Wellwood, North Farm Road,
Tunbridge Wells, Kent TN2 3DR

Diagrams and text copyright © Janet Wilson and
Tiny van der Plas 2008

Photographs by Debbie Patterson at Search Press studios

Photographs and design copyright © Search Press Ltd 2008

ISBN: 978-1-84448-301-3

The Publishers and author can accept no responsibility for
any consequences arising from the information, advice or
instructions given in this publication.

Readers are permitted to reproduce any of the items in this
book for their personal use, or for the purposes of selling
for charity, free of charge and without the prior permission
of the Publishers. Any use of the items for commercial
purposes is not permitted without the prior permission of
the Publishers.

Suppliers
If you have difficulty in obtaining any of the materials and
equipment mentioned in this book, then please visit the
Search Press website for details of suppliers:
www.searchpress.com

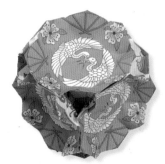

Publisher's note

All the step-by-step photographs in this book feature
the co-authors, Janet Wilson and Tiny van der Plas,
demonstrating the craft of tea bag folding.
No models have been used.

Printed in China.

Acknowledgements
We would like to thank the following
for their help and generosity:
Letraset
Glue Dots™
Efco Hobby Materials
Starform stickers
Pebeo
Paper Cellar
Texere Yarns
Dovecraft
Fiskars
Cardcraft Plus

Instructions for the alternative designs shown in the
photographs following the projects are also available at
the Search Press website.

Tea bag folding papers
All of the tea bag folding papers that you need to make
everything in this book, along with additional designs,
are available in *Janet & Tiny's Tea Bag Folding Papers*,
ISBN 978-1-84448-395-2, published by Search Press.

Cover: Japanese kusudama
*The kusudama fold displays the crane bird which in Japan
signifies both good fortune and happiness.*

Page 1: Memories of Al-Andalus
*This elegant sponged box canvas will evoke images of
beautiful Moorish tiles and the warmth of the Andalucian
sun into your home.*

Page 3: Irish necklace
A beautiful Celtic pendant necklace.

Opposite: Indian jewellery box
*An opulent Mogul-style chest in
which to store your jewels.*

Contents

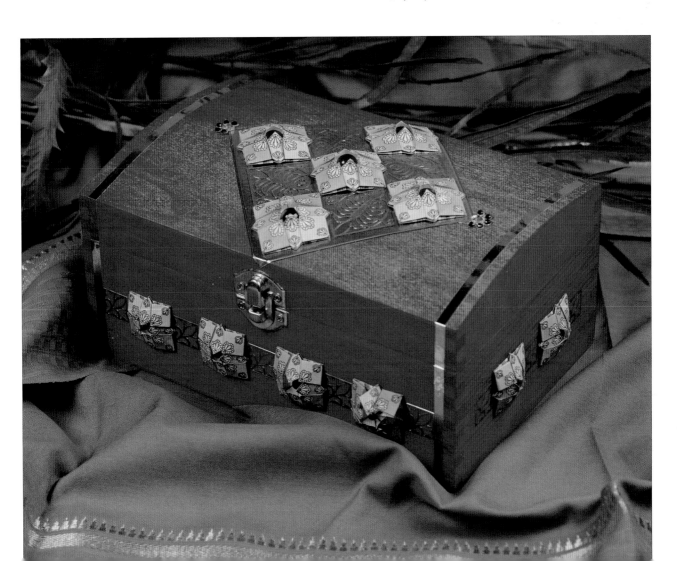

Introduction

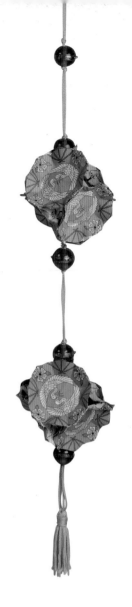

We first met up in 1992 and it was at that first meeting that Tiny showed Janet her new origami idea: instead of using dedicated origami paper Tiny had used the fronts of the gaily patterned envelopes in which fruit tea bags are sold. Like most good ideas it happened quite by accident – in this case a lapse of memory! This lapse introduced many, many people to the ancient art of paper folding known as origami.

This is the third book that we have written together and, as usual, there was a lot of fun and laughter as we batted ideas for themes, projects and inspirational pieces back and forth between us. We hope that you have as much fun and pleasure out of making the projects as we had designing them.

Happy folding!

Publisher's note:

This book contains all of the instructions, templates and tea bag papers that you need to make the projects, but Janet and Tiny have crammed this book so full of ideas that some of them have had to be put in a companion volume!

Janet & Tiny's Tea Bag Folding Papers contains enough papers to make all of the main projects as well as all of the alternative designs shown on pages 23, 29, 37, 43, 53 and 61 of this book.

It also has some tea bag papers from Janet and Tiny's previous books, *Tea Bag Folding* and *More Tea Bag Folding*, as well as some exclusive tea bag papers available nowhere else for you to try your own ideas out.

It is available from the Search Press website (www.searchpress.com), which also has free access to all of the templates needed to make the alternative designs.

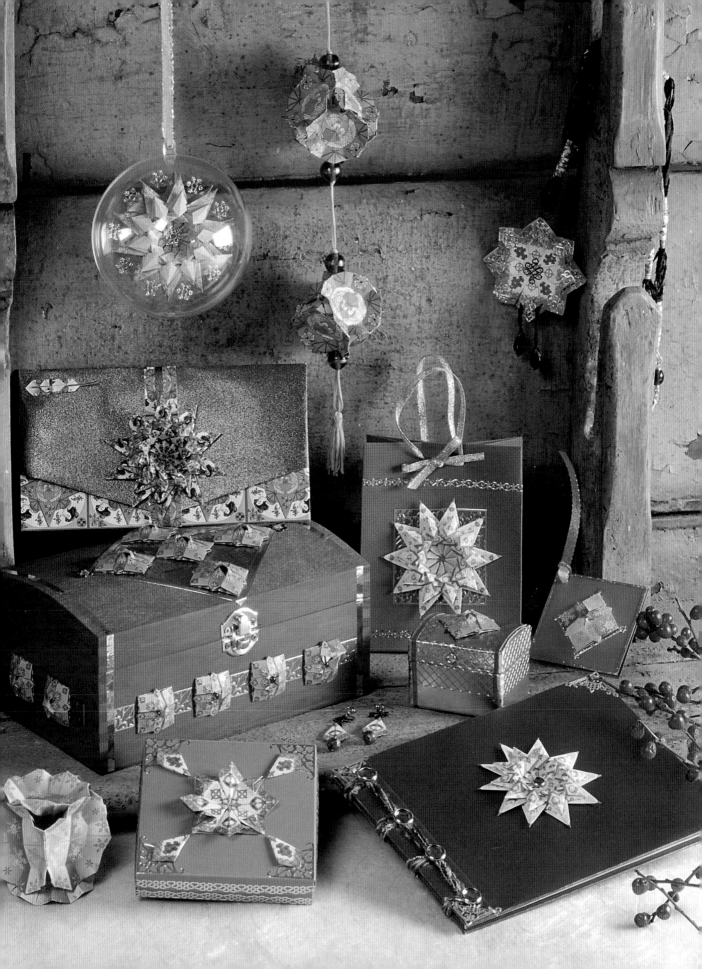

Materials

Tea bag papers

The papers at the back of the book are sufficient to make all of the main projects and a companion book is available that contains enough papers to make all the projects, all the variations in this book and still have a few remaining! It also contains some of the papers from our previous two books (*Tea Bag Folding* and *More Tea Bag Folding*) for good measure.

These are very versatile papers and you can use the different papers for each of the folds (try using the Ireland paper with the fold from the canvas art project on pages 24–27, for example). This will give each project an entirely different look!

The papers are designed so that you can get a different look if you start with a different corner to that suggested in each project, or you can get another look by making the fold using a homemade tea bag square. If you like fruit tea then you usually need to drink around eight cups to get enough paper envelopes to cut into squares to make a rosette. Be creative and experiment.

Tip

Paper blunts a knife more quickly than most other materials so make sure you have spare blades available.

Paper and card

We have used **pearl card** and **paper** from some of the projects as these give a wonderfully lustrous finish to your finished work.

Holographic paper has been used in the star book project (see pages 54–59) to produce the gleam and glitter of snow and ice.

Coloured card and **paper** have been also been used for certain projects and for the variations.

Thick card is a must for making book covers and for supporting tea bag jewellery such as the Celtic pendant (see pages 14–21). We simply save thick card from packaging or hard-backed envelopes, but you can purchase sheets of card in varying thickness from retailers.

Tip

If you want to make any of the projects using a different tea bag paper choose coloured card or paper that complements the fold.

Blanks

A **wooden chest box blank** and a **box canvas** have been used for two of the main projects. If you have difficulty in getting these from your local arts and crafts stockist log on to the Search Press website and click on materials list to find stockist details.

The square boxes shown on pages 23 and 29 were made by Janet, and the templates are available on the Search Press website.

Embellishments

Outline stickers These very versatile stickers have been used to decorate tea bag folds, jewellery, metal, cards, books and they have even been used to create the tile effect on the box canvas project.

Beads Small rocaille (or seed) beads and a variety of other glass beads have been used in several projects. You do not have to use exactly the same beads as we have; look through your stash to see what you have in a suitable size and colour for your chosen project. Beads can be bought from many retailers and specialist bead shops. You will be spoilt for choice!

Decorative brads There is a huge choice of brads of all shapes and sizes on the market today. Janet has a penchant for jewelled brads but you can, of course, choose different ones to enhance your projects.

Craft jewel flower embellishments These come in flower shapes, paisley shapes and lots of other shapes too, and they also come in different colours. These can often provide a perfect finishing touch to a project.

Ribbon Again, there is a wonderful range of types, colours, widths and materials to choose from. Choose one you like to enhance your work.

Chenille yarn This has been used in the making of the Celtic pendant (see pages 14–21) as it gave just the look we wanted. You can of course choose another suitable yarn that appeals to you. It is available from specialist yarn retailers or you may find it in the wool sections of department stores.

Kusudama cord This is not always easy to get hold of although some retailers specialising in origami or Japanese products may well have it. You can substitute **cotton embroidery thread** produced by several of the well-known embroidery thread manufacturers.

Jewellery findings Eye pins, jump rings and magnetic fasteners can be obtained from the many retailers who stock jewellery items such as beads.

Other materials

Pliers Janet uses bent-nosed pliers to pick up and hold jewellery findings, and plastic-nosed pliers to flatten and harden wire.

Circle cutter This is very useful for cutting curves and circles for decoration and embellishment. A compass is a good alternative.

Acrylic paints, spatula and sponge The spatula is used for mixing the paint, while the sponge is used to apply it. A real sponge is preferable to an artificial one. Both should be washed out immediately after use in warm water. Once used for paint, a sponge must be kept as a dedicated paint item and not used for washing oneself with!

Cutting ruler, cutting mat and scalpel A sharp craft knife or scalpel is important as a blunt blade will not give a clean cut. You will also need a cutting mat and a steel-edged ruler (cutting ruler) to ensure safety and to protect your surface.

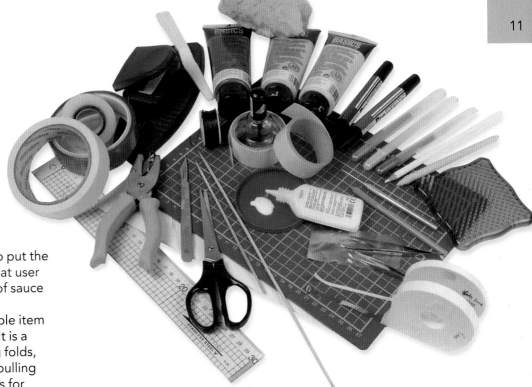

PVA glue We prefer extra-tacky PVA glue as this bonds more quickly.

Plastic lid This is used to put the glue on to. Janet is a great user of plastic lids from tubs of sauce or gravy granules!

Cocktail stick This humble item is Tiny's secret weapon. It is a great tool for smoothing folds, turning fiddly folds and pulling out inner layers as well as for applying small dots of glue when putting the folds together into rosettes. Have one in the glue tray and a clean one within easy reach when folding.

Double-sided sticky tape and **low-tack sticky tape** Handy for securing templates to card or paper whilst cutting out.

Low-tack masking tape Used in the canvas art project (see pages 24–27) to mask already painted sections and to hold the template in place.

3mm (⅛in) white letraline flex-a-tape Used round the edges and in the centre of a box canvas in the canvas art project to create a tiled effect.

Wire jig, six pegs and dark green 22 gauge wire These are used to create the shape in the centre of the Celtic pendant (see pages 14–21).

Scrap paper Always a useful standby to try out folds, patterns, test paint, coloured pencils, marker pens and so forth, and also for protecting surfaces.

Bamboo skewer This is used to roll paper beads.

Paper stump These are used by artists to blend pastels and charcoal. Since Janet used them in several of her books a number of craft retailers now sell these along with metallic paper and metal sheet! You can find them in art shops or in the art sections of large stores.

Tweezers Curved or straight tweezers are a must when using outline stickers or picking up cabochon beads.

Glue dots The very tiny dots in this range are excellent for sticking cabochons, sequins etc. on to projects.

Marker pen Permanent markers are excellent for colouring the box blanks or the edges of the cardboard mounts used in the jewellery projects.

Gold embossing foil Lay on stencils or on the residue left on an outline sticker sheet and gently rub with a paper stump to create a raised pattern as we have done in the India project. It is also used with an embossing tool.

Metallic gold tape Use for covering card edges or when decorating items.

White pencil If using a dark surface a white pencil makes and ideal marker alternative to a pencil and, if used lightly, it can be easily removed with an eraser.

Snowflake border punch Used to create decorative border strips in the star book project (see pages 54–59).

Hole punch These come in several sizes and in this book have been used to punch holes in the spine of an album.

Beading needle This needle opens up in the centre so you can slip the thread or fibre you want to use through it with ease.

Clear nail varnish Painted on to paper jewellery, nail varnish protects and strengthens the item.

Piercing tool and mat Ideal for pre-making holes when sewing beads or wire projects on to cards.

Glaze gel pens These create slightly raised jewel-like areas when used.

Origami symbols

Tea bag folding is a form of modular origami and, as such, has diagrams showing each stage of the folding project. On each diagram there are symbols that tell you various things such as which way the paper should fold, when to turn it over etc. and these can be very baffling if you are new to origami, particularly as one diagram may well contain instructions for two or three different steps!

If you have been put off trying tea bag folding because of this, now is the time to try again. In each of the projects, Tiny shows you in the step-by-step photographs how each fold is made and a reference is given as to which diagram she is using. By referring to the photo and the relevant diagram you will soon learn what all those curious symbols mean.

All of the international origami symbols used in this book are shown on these pages, so you can use this to refresh your memory if you are unsure what to do.

Tip

Take your time and look at each diagram step carefully. The arrows show you in which direction the paper has to be folded.

Tip

Practise each new fold on a larger square of scrap paper before using your precious tea bag papers.

Key to diagrams

Front and back of the paper

The front of the paper is indicated in grey like this.

The back of the paper is shown as white like this.

Valley fold

A valley fold is indicated by a dashed line whilst the arrow shows you which way to fold.

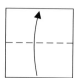

Mountain fold

A mountain fold is indicated by a dashed and dotted line; the strange-looking white arrow indicates that the paper is folded to the back.

Fold and open

A double-ended arrow indicates that you fold the paper in the direction of the top arrow and then open it out as indicated by the bottom of the arrow. As the paper is shown as white it means that the back of the paper is uppermost in this case.

Turn round

The two arrows chasing themselves indicate that you need to turn the paper round; the next diagram will show you which way it should be.

Turn over

The arrow that looks like a horn means turn the paper over, the colour of the next diagram tells you which way it goes.

Pull out layer between

The large outlined arrows indicate that you should pull out the layer between and the next diagram shows you how it should look.

Push in or open out

If you see just an arrowhead (no shaft) then this indicates that the fold it points to should be pushed in or opened out. The arrow shows you where it should go and the next diagram will show you how it should look.

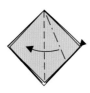

Enlargement arrow

If you see an open arrow like this it means that the diagram has been enlarged so that you can see in more detail the next step.

Repeat

Sometimes you may see this arrow with more lines across it; repeat the step the same number of times as the lines that cross the arrow.

 An arrow with a line across it means repeat this step once more.

 An arrow with two or more lines across means repeat this step twice or more.

Slide under

A diagram with an arrow that starts with a line and then changes to a small dashed line with an arrowhead means that you slide either the element or paper under or between the layers.

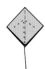

Cut

If you see the outline scissor symbol this indicates that you should cut where the blades touch the diagram.

Land of Saints and Scholars

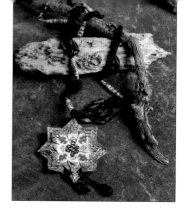

The designs on the tea bag folding paper depict some of the numerous facets of Irish heritage: the Celtic knot, the shamrock, the Tara brooch and the Claddagh.

The Celtic knot symbolises the Thread of Life, an unbroken chain of man's eternal spiritual growth, while the shamrock was used by Saint Patrick to explain the mystery of the Trinity, three in one. The Tara brooch has no known connections whatsoever to the Hill of Tara, seat of the (semi-mythological) High Kings of Ireland. Instead, the brooch on the paper is similar to one found along the sea shore in County Meath and currently on display in the National Museum of Ireland. The brooch dates from around AD 700 and is an example of how advanced goldsmithing techniques were at that time.

In the very centre of the tea bag paper is the Claddagh, a symbol of enduring love. The heart represents that love, the crown symbolises undying loyalty, and the hands are a symbol of friendship which is the foundation of love and loyalty and holds the two together. If you wear a Claddagh ring on your right hand, heart facing outwards, you are showing that your heart has not yet been won. If you wear it with the heart facing inwards, it means you have friendship/love under consideration. Worn on your left hand with the heart turned inwards means two loves have joined together forever.

You will need

- Cutting ruler and mat
- Scalpel
- Cocktail stick
- Bamboo skewer
- PVA glue
- Five 5 x 5cm (2 x 2in) and four 4 x 4cm (1½ x 1½in) Ireland tea bag papers
- 8 x Ireland tea bag paper chevrons (see tea bag paper section)
- Thick cardboard
- Green marker pen
- Sticky tape and double-sided sticky tape
- Starform outline sticker sheets – 1070 and 1069 (gold)
- Wire jig with six pegs
- Dark green 22 gauge wire
- Clear nail varnish
- Eight 75cm (29½in) and four 8cm (3in) strands of thin dark green chenille yarn
- Six small and six medium gold-coloured rocaille beads
- Piercing tool and mat
- Gold metallic thread
- Large-eyed beading needle
- Sixteen long oval, two teardrop and two round dark green Indian glass beads
- 4 x 45mm (1¾in) gold eye pins
- 4 x 5mm (¼in) gold jump rings
- Gold magnetic fastener
- Pencil
- Plastic-nosed pliers

Folding diagram

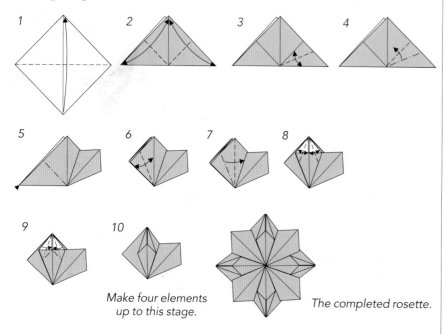

1 *2* *3* *4*

5 *6* *7* *8*

9 *10*

Make four elements up to this stage.

The completed rosette.

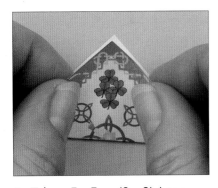

1. Take a 5 x 5cm (2 x 2in) tea bag and fold it in half diagonally so the pattern is on the outside and the shamrock is at the top as shown. See diagram 1.

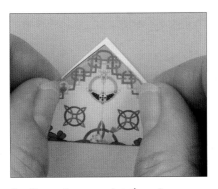

2. Open it up, twist the piece clockwise through ninety degrees, and fold along the diagonal as shown. See diagram 1.

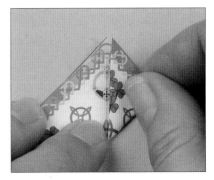

3. Fold the point on the right-hand side up to the top point. See diagram 2.

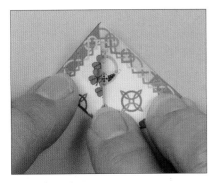

4. Fold the point back down, then repeat on the other side, folding the left-hand point up to the top point. See diagram 2.

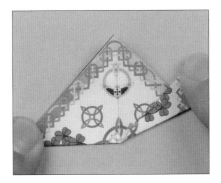

5. Fold the point back down, then fold the right-hand point across the crease made in step 3 as shown. See diagram 3.

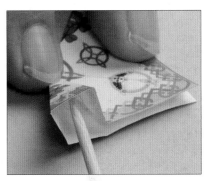

6. Fold the point back down, then use a cocktail stick to open up a pocket. See diagram 4.

7. Flatten the pocket gently as shown. See diagram 4.

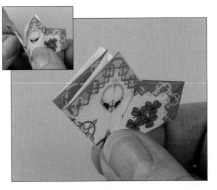

8. Fold the left-hand point inside (see inset), then flatten the paper. See diagram 5.

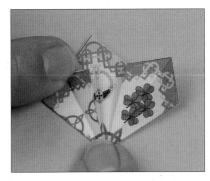

9. Fold the upper part of the left-hand side over to the centre as shown. See diagram 6.

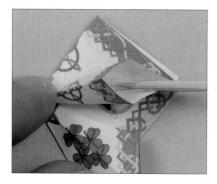

10. Fold the upper part back to the corner, then use the crease made to create a pocket. Open the pocket with a cocktail stick. See diagram 7.

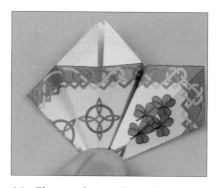

11. Flatten the pocket. See diagram 7.

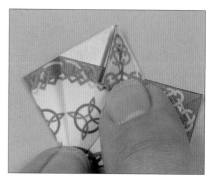

12. Fold the top right side of the pocket over to the centre. See diagram 8.

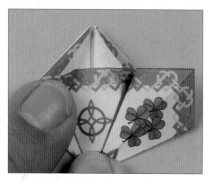

13. Open it out and repeat on the top left of the pocket. See diagram 8.

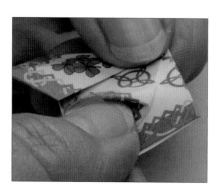

14. Fold along the crease from step 12 to tuck the left side into the pocket. See diagram 9.

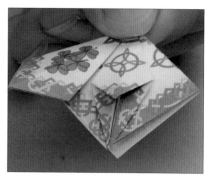

15. Repeat on the right-hand side, folding into the crease from step 13. This completes one element. See diagram 10.

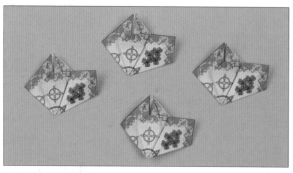

16. Make another three elements in the same way.

Tip
Slide the elements together to see how they fit before you secure them with a dab of glue.

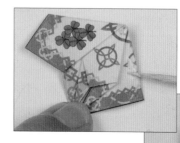

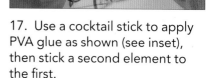

17. Use a cocktail stick to apply PVA glue as shown (see inset), then stick a second element to the first.

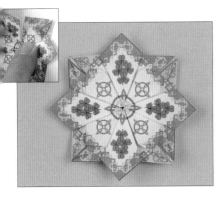

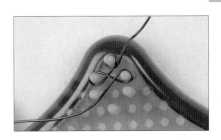

18. Attach the other two in the same way, then lift the right-hand part of the first element (see inset) and stick it to the left-hand part of the fourth to complete a rosette.

19. Make a second rosette using 4 x 4cm (1½ x 1½in) tea bag papers, then use tweezers to carefully apply outline stickers on the points of both.

20. Set up your wire jig as shown, and hook a 20cm (7¾in) wire round the top peg, leaving a 2.5cm (1in) end as shown. Carefully wind the wire round the top peg, then under and round the upper left peg, then under and round the upper right peg.

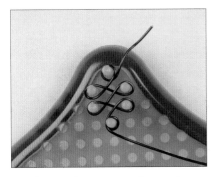
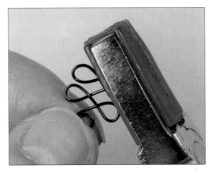
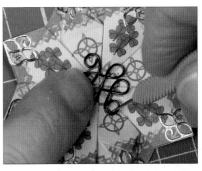

21. Wind the wire under and round the lower left peg, under and round the lower right peg, then over and round the bottom peg.

22. Carefully lift the wire off the jig, trim the ends and use plastic-nosed pliers to flatten and harden the shape.

23. Place the wire embellishment on the smaller rosette, and use the piercing tool to make holes just inside each loop of the wire.

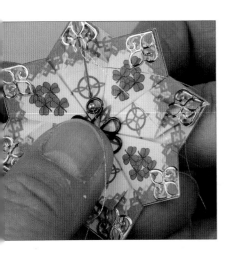

24. Thread a needle with 30cm (12in) gold metallic thread. Take it up from the back through the top hole and secure with a bit of sticky tape. Take the needle through the wire embellishment, pick up a small rocaille bead, then take it over the wire and back through the same hole.

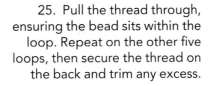

25. Pull the thread through, ensuring the bead sits within the loop. Repeat on the other five loops, then secure the thread on the back and trim any excess.

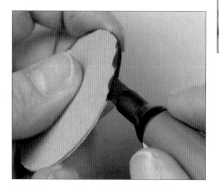

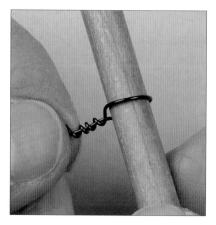

26. Cut a 5cm (2in) circle from thick cardboard and run the green permanent marker round the edge.

27. Attach a 5 x 5cm (2 x 2in) tea bag paper with double-sided tape and carefully cut away the excess (see inset).

28. Wrap a 7cm (2¾in) piece of wire round a pencil, then twist the pencil to make the wire into a spiral with a loop.

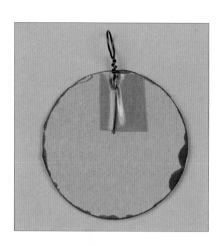

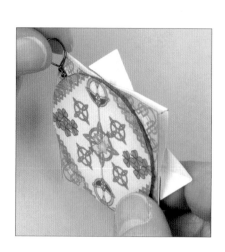

29. Use sticky tape to attach the loop to the cardboard circle as shown, making sure the Claddagh is the right way up on the reverse.

30. Carefully varnish the rosette with clear nail polish and set it aside to dry.

31. Secure the larger rosette to the blank side of the cardboard using double-sided tape.

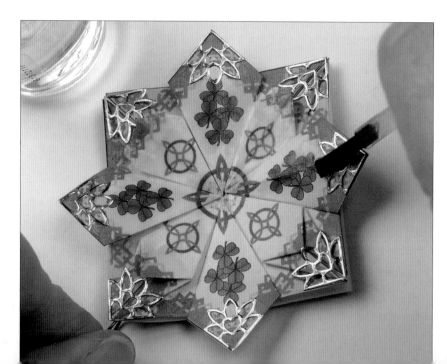

32. Thread two 8cm (3⅛in) lengths of dark green chenille on to a large-eyed needle, then thread a large green glass bead and tie a knot with the chenille to secure the bead. Remove the needle and repeat to make two dangles.

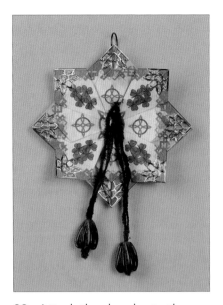

33. Attach the dangles to the middle of the larger rosette with double-sided sticky tape.

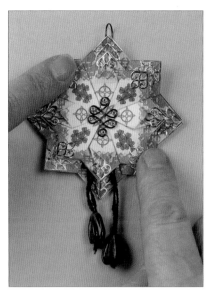

34. Varnish the smaller rosette, allow it to dry and attach it on top of the 5 x 5cm (2 x 2in) piece to complete the pendant.

35. Cut out one of the chevrons from the tea bag papers using a craft knife and cutting mat, then rub a bamboo skewer under the broad end to encourage a curl.

36. Starting at the broad end, carefully roll the paper tightly round the skewer. As you near the point, spread PVA glue over it and finish rolling the bead. Allow to dry, then apply outline stickers on the centre and varnish the piece to make a bead. Make seven more in the same way.

37. Take eight 75cm (29½in) strands of green chenille. Thread them through the loop of the pendant and feed them through until the pendant hangs in the centre.

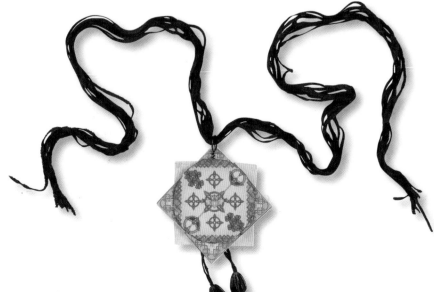

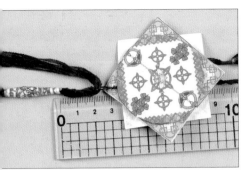

38. Thread the strands of chenille through a large-eyed needle, and take it through a paper bead. Run the bead down to 2cm (¾in) from the pendant.

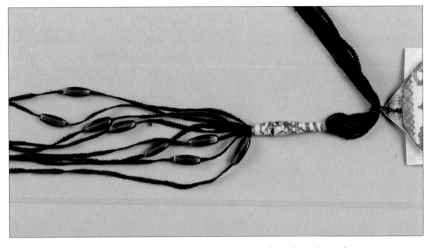

39. Working one strand at a time, thread eight glass beads on to the chenille, and run them down to sit in a staggered fashion above the paper bead.

Tip

Take four threads through at a time. If you try to thread all eight at once, the needle could break.

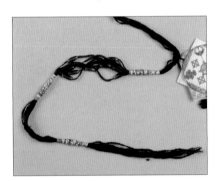

40. Run two more paper beads on in the same manner as the first, leaving 10cm (4in) from the first and 7.5cm (8in) from the second bead as shown.

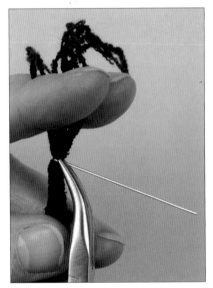

41. Open an eye pin with round-nosed pliers. Hook it around all eight strands of chenille near the ends, then close the eye with angled pliers.

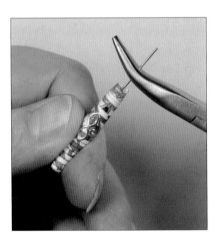

42. Dab varnish on to the chenille in the eye, then thread a paper bead on to the remaining chenille. Use angled pliers to pull the eye pin through if necessary.

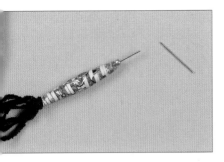

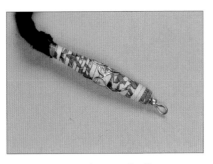

43. Thread a medium gold rocaille bead on to the eye pin. Leaving 1cm (½in) of wire from the eye pin, trim the excess.

44. Use round-nosed pliers to bend the wire into an eye.

45. Thread a medium gold rocaille bead, a green glass bead and another medium gold rocaille bead on to an eye pin and make an eye at the straight end to secure them.

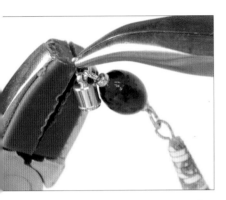

46. Use a jump ring to secure the necklace to the beaded eye pin, then use another to secure one half of a magnetic pendant to the other end of the beaded eye pin.

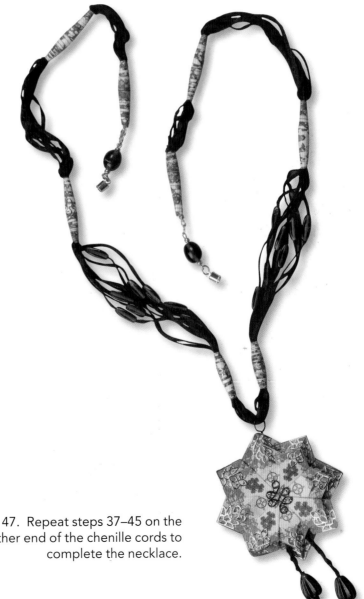

47. Repeat steps 37–45 on the other end of the chenille cords to complete the necklace.

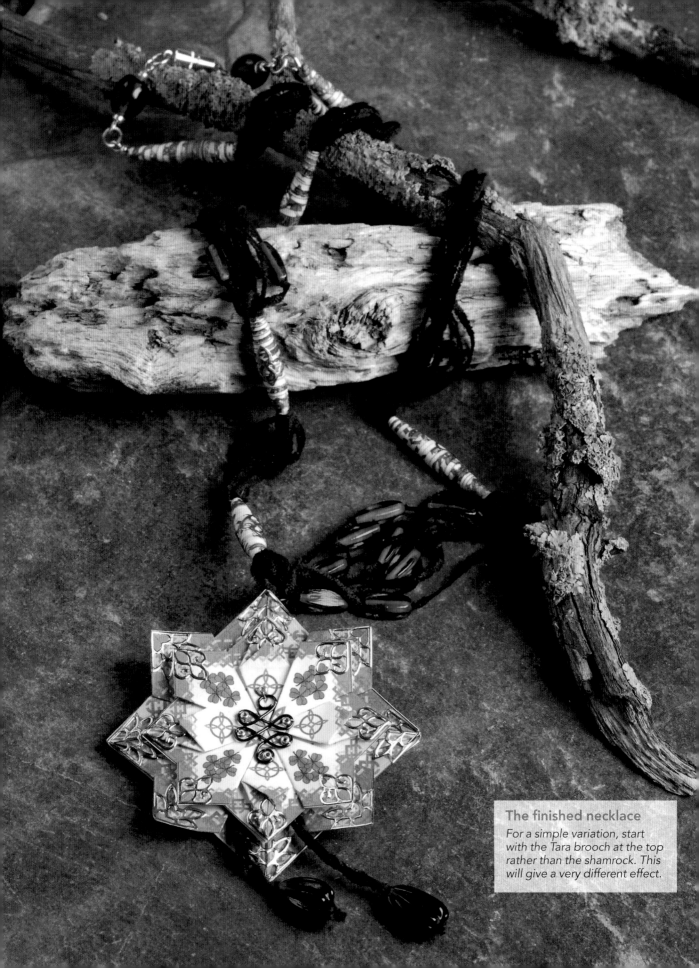

For a simple variation, start with the Tara brooch at the top rather than the shamrock. This will give a very different effect.

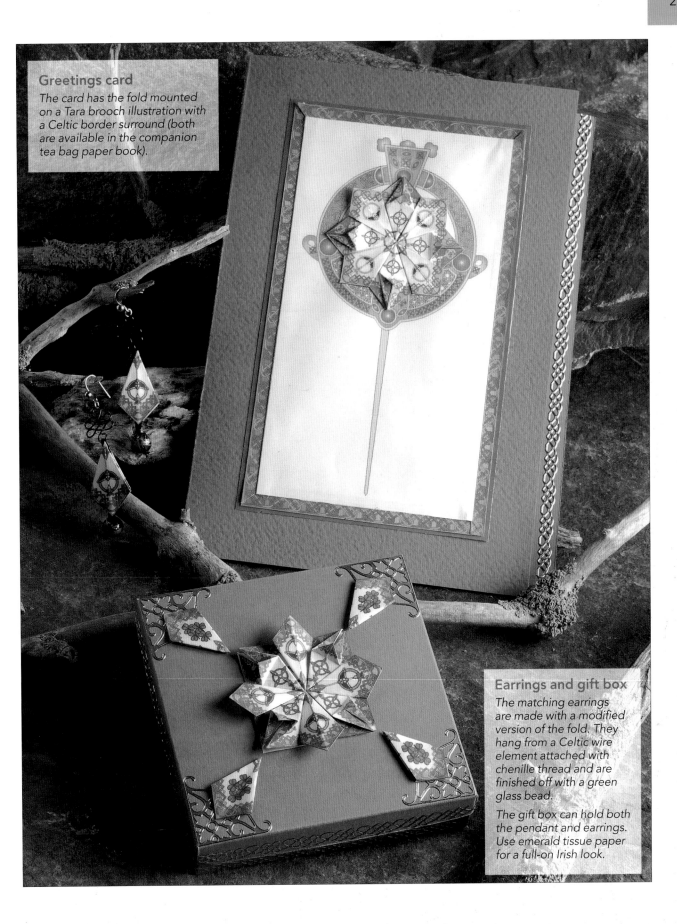

Greetings card

The card has the fold mounted on a Tara brooch illustration with a Celtic border surround (both are available in the companion tea bag paper book).

Earrings and gift box

The matching earrings are made with a modified version of the fold. They hang from a Celtic wire element attached with chenille thread and are finished off with a green glass bead.

The gift box can hold both the pendant and earrings. Use emerald tissue paper for a full-on Irish look.

The Heart of Moorish Spain

Andalucia abounds with wonderful Moorish architecture and decorations that have inspired artists and delighted all who have seen them from the eighth century to this day. We can see the legacy of the Moors in present-day Spain's arts and crafts, as well as brick, plaster, wood, leather, pottery and textiles from the region. Europe learnt about navigational aids, mathematics, medical science and even the wisdom of Ancient Greek philosophers in scholarly Cordoba.

The Moors learnt the secrets of papermaking from the Orient and introduced it into Spain in the year 1150. They built the first working paper mill in Europe in 1238. The inspiration for the folding paper design was a pearl lustre tile, probably imported from Persia, as it is in the style of Kashan.

You will need

- Cutting ruler and mat
- Scalpel
- Cocktail sticks
- PVA glue
- Thirty-six 4 x 4cm (1½ x 1½in) and nine 5 x 5cm (2 x 2in) tea bag papers
- 25.5 x 25.5cm (10 x 10in) box canvas
- 6mm (¼in) super-sticky double-sided tape
- 25mm (1in) low-tack masking tape
- Paper Cellar craft jewel flowers – Complements flower shapes 1
- Starform line sticker sheet – 1016 (gold)
- 3mm (⅛in) white Letraline flex-a-tape
- Acrylic paints - light yellow, dark yellow and red
- Sponge and spatula

Folding diagram

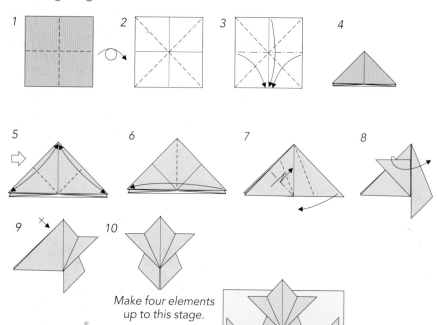

Make four elements up to this stage.

The completed rosette, made up of four elements mounted on a 5 x 5cm tea bag paper.

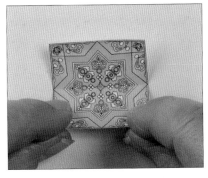

1. Take a 4 x 4cm (1½ x 1½in) tea bag paper and place it colour-side up. Fold the bottom half up to the top, then open it up, leaving a crease. See diagram 1.

2. Turn the paper ninety degrees clockwise, then fold the bottom up to the top as shown and open it up again. See diagram 1.

3. Turn the piece face-down and fold it in half along the diagonal. See diagram 2.

4. Open the piece up, turn it and fold along the other diagonal before opening it up. See diagram 2.

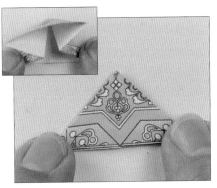

5. Fold the left and right sides in as shown in the inset (see diagram 3), then gently flatten it until the top and bottom sides meet. See diagram 4.

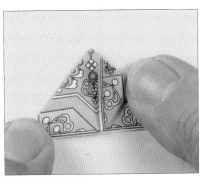

6. Fold the top layer of the right tip up to the top. See diagram 5.

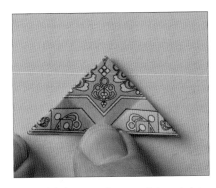

7. Fold the top layer of the right tip up to the top, then fold both back down to make the creases shown here. See diagram 5.

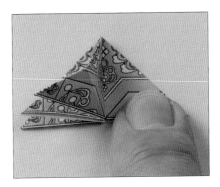

8. Fold the top layer of the right over to the left. See diagram 6.

9. Fold this layer in on itself to the centre, using the creases made in steps 5–7. This makes a new top layer for the left-hand side. See diagram 7.

10. Fold the right-hand side down to form a point as shown. See diagram 8.

11. Fold the new top layer of the left-hand side over the point. See diagram 8.

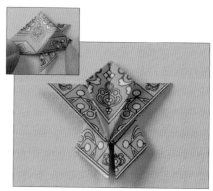

12. Fold the original top layer of the left-hand side over as shown in the inset (see diagram 8), then repeat steps 9–11 on the side this reveals. See diagram 9.

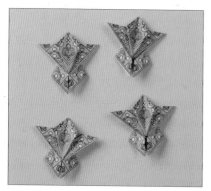

13. Make three more elements in the same way.

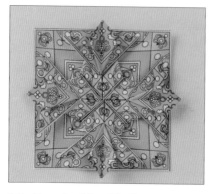

14. Use double-sided tape to secure all four to a 5 x 5cm (2 x 2in) tea bag paper as shown. Make eight more rosettes in the same way.

15. Protect your surface with scrap paper, then place the template (see page 62) in the centre of the canvas and go round it with masking tape.

16. Lift the template away. Mix a touch of red acrylic paint with yellow paint, and use a damp sponge to apply the mix inside the masked-out area.

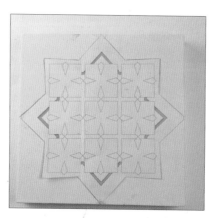

17. Allow to dry, then carefully remove the masking tape. Place the template over the coloured area and use masking tape to secure it in place.

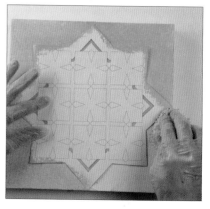

18. Mix light yellow acrylic paint with a touch of red to make a lighter orange, and apply it round the edges with a sponge as shown.

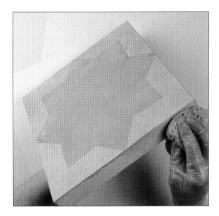

19. Carefully remove the template, touch up any white patches and sponge the edges in the same way. Allow to dry.

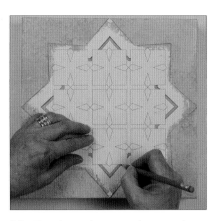

20. Replace the template and use a pencil to make marks in each cut out part.

21. Run 3mm (⅛in) white flex-a-tape along each pencil line and along the outer edge of the canvas, leaving spaces at the points of the stars as shown.

22. Use long outline sticker strips to decorate the canvas, using the outline of the star to help with positioning. Run the strips right over the edges of the canvas (see inset).

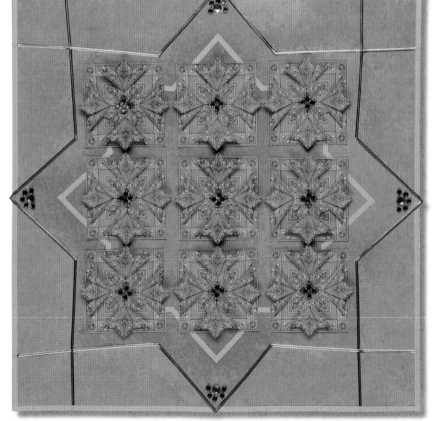

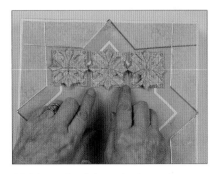

23. Use double-sided tape to attach a row of three tea bag rosettes to the central part of the star as shown.

24. Attach the rest of the rosettes with double-sided tape, then decorate the piece with the craft jewel flowers (those in the centre of the folds have been cut in half) to finish.

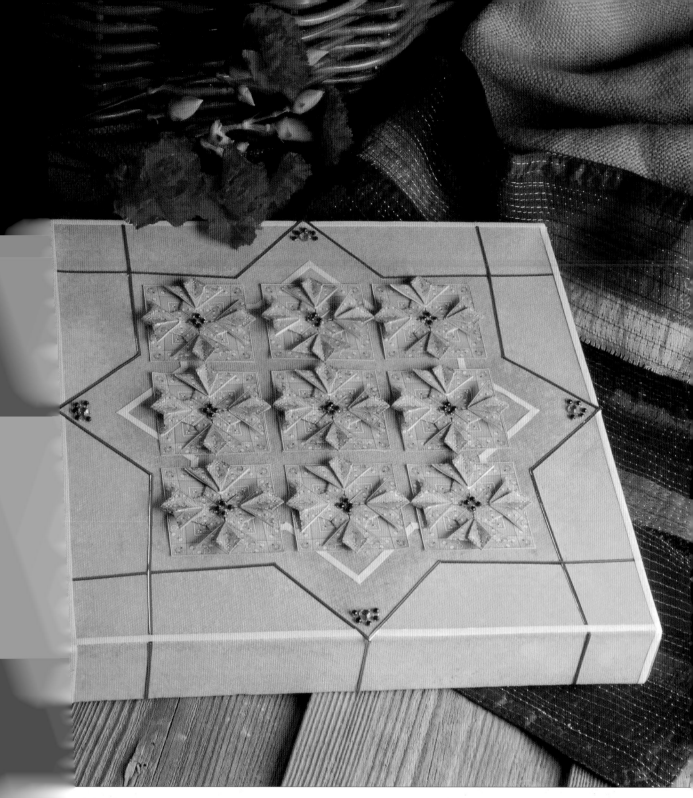

nished canvas art

re evocative of sun, sand, glorious architecture and tiles.

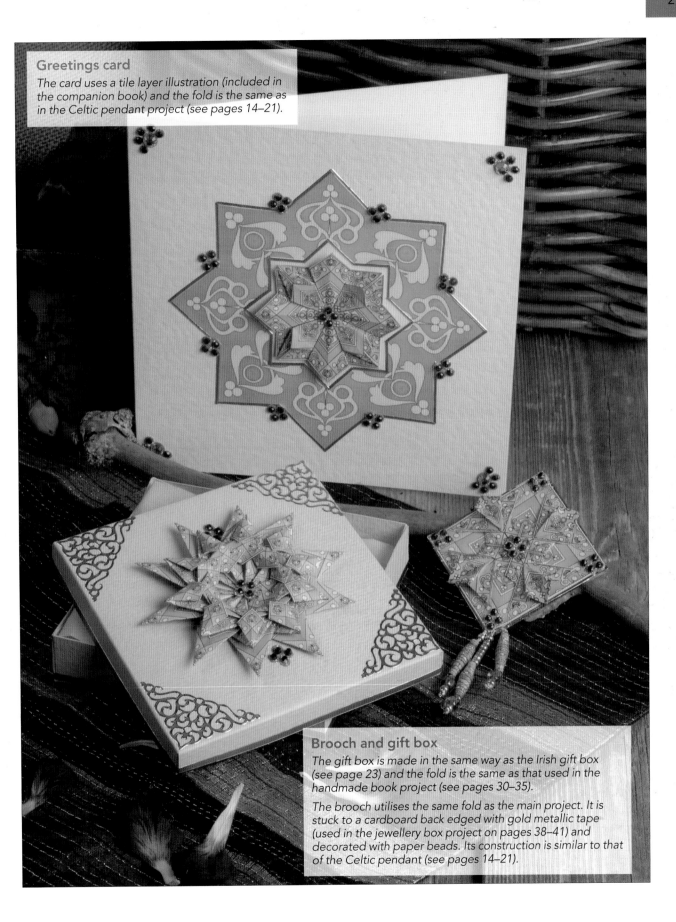

Greetings card

The card uses a tile layer illustration (included in the companion book) and the fold is the same as in the Celtic pendant project (see pages 14–21).

Brooch and gift box

The gift box is made in the same way as the Irish gift box (see page 23) and the fold is the same as that used in the handmade book project (see pages 30–35).

The brooch utilises the same fold as the main project. It is stuck to a cardboard back edged with gold metallic tape (used in the jewellery box project on pages 38–41) and decorated with paper beads. Its construction is similar to that of the Celtic pendant (see pages 14–21).

Where East Meets West

Russia is the birthplace of many famous composers, writers, poets and artists: Tchaikovsky, Rimsky-Korsakov, Mussorgsky, Pushkin, Fabergé to name but a few.

The tea bag paper design includes two Matryoshkas (Russian nesting dolls), one in the Semionova style (painted mainly with red and yellow and decorated with flowers, often roses, on the apron) and the other is Zagorsk monastery style (a slimmer version). The concept of nesting dolls originated in Japan and was developed by the Russians. These nesting dolls can now be bought in many different styles, colours and patterns.

The samovar (tea urn) came into being in the eighteenth century after the introduction of tea into Russia from West Mongolia. The first samovar factory was founded in Tula in 1778. They are not only a domestic utensil but can be real works of art as well. Richly decorated, made of silver or plated with gold, they come in different shapes – vases, pears, wine glasses, and many other forms.

The paper also features a version of the coat of arms of Imperial Russia before 1917. At this time the central shield depicted the arms of Moscow, namely St George and the Dragon, but our version replaces this with the Russian flag.

You will need

- Cutting ruler and mat
- Scalpel
- Cocktail sticks
- PVA glue
- Ten 4 x 4cm (1½ x 1½in) tea bag papers
- Two 19 x 14.5cm (7½ x 5¾in) pieces of thick cardboard
- Four A4 sheets regal blue pearl paper
- Ten A4 sheets 100gsm ivory laid paper
- One A4 sheet white patterned vellum
- 65cm (25½in) of blue fibres and ribbons
- Dark blue jewel brads
- Eight Starform silver corner outline stickers
- 5mm (¼in) hole punch
- 2.5cm (1in) wide masking tape
- 6mm (¼in) wide double-sided sticky tape
- 6mm (¼in) wide double-sided sticky tape
- Folding bone
- One 2 x 2cm (¾ x ¾in) piece of white paper

Folding diagram

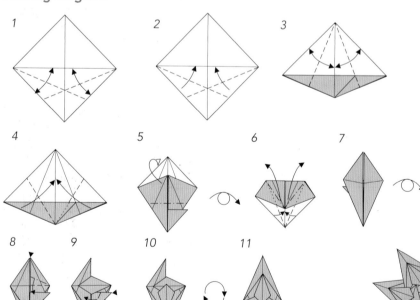

Make ten elements up to this stage.

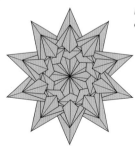

The completed rosette, made up of ten elements.

1. Place a 4 x 4cm (1½ x 1½in) tea bag paper face-down and fold along the diagonal so the blue samovar is at the top.

2. Open the paper out, turn it ninety degrees clockwise, and then fold along the diagonal so the blue doll is at the top.

3. Open the paper out and fold the bottom right side across the crease (see inset), then repeat on the bottom left side. See diagram 1.

4. Open the paper up and fold both of the sides in along the crease. This will form a point (see inset). Fold the point over to the left as shown. See diagram 2.

5. Fold the top right side over to the middle.

6. Fold the top right side back, fold the point over to the right, and fold the top left side over to the middle. See diagram 3.

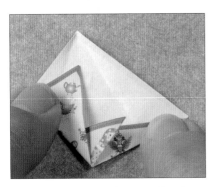

7. Fold the top left piece back, then fold the bottom left side up as shown. See diagram 4.

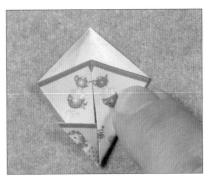

8. Fold the point over the bottom left side, and fold the bottom right side up. See diagram 5.

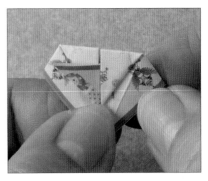

9. Fold the top part of the paper (just above the point) backwards so that it goes under the bottom. See diagram 5.

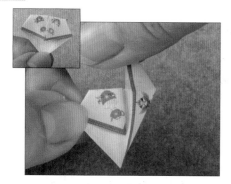

10. Turn the whole piece over (see inset) and lift the right point along the creases. See diagram 6.

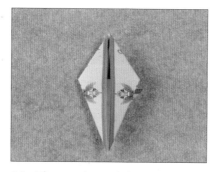

11. Flatten the right part down and repeat on the left. See diagram 7.

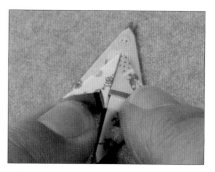

12. Turn the whole piece over and fold the bottom left part up so that it is vertical. See diagram 8.

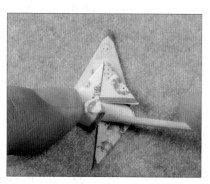

13. Put a cocktail stick in the vertical part, and flatten it. See diagram 9.

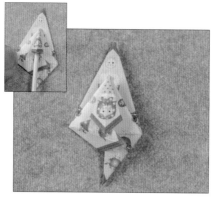

14. Lift the point up, insert a cocktail stick and flatten it (see inset). This completes one element. See diagram 10. Make nine more.

Note

Make sure you always start with the same corner when folding the elements you need. Janet incorporates subtle changes of colour and symbols when she designs the papers to make them as versatile and interesting as possible.

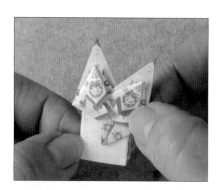

15. Take a 2 x 2cm (¾ x ¾in) square of white paper, and use double-sided tape to attach it to an element. Slot the next element in as shown.

16. Repeat until all ten are in place to make a rosette.

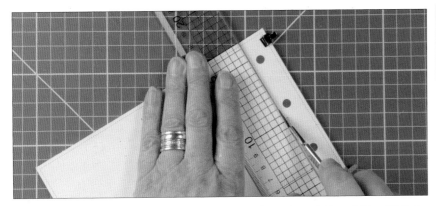
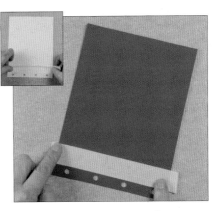

17. Secure the template (see page 63) to the 19 x 14.5cm (7½ x 5¾in) piece of mountboard with tiny bulldog clips. Use the 5mm hole punch to make the hole in the spine, then place it on the cutting mat and use a craft knife to cut the spine away.

18. Attach the spine to the cover using masking tape, leaving a tiny gap to act as a hinge (see inset). Turn the piece over and place masking tape on the other side.

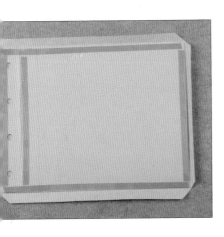

19. Place an A4 sheet of blue paper face-down, then place the cover in the centre. Cut the corners off the blue paper, then run double-sided tape along the cover as shown.

20. Remove the backing from the tape and fold in the paper on the edges. Re-punch the holes in the spine with the 5mm hole punch.

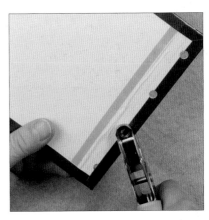

21. Turn the cover over and gently score the hinge with a folding bone. Check the hinge works at this point.

22. Attach an 18 x 13.5cm (7 x 5¼in) piece of blue paper to the inside cover as lining, then re-punch the holes to complete the front cover.

23. Make a back cover in the same way, but do not make a hinge.

24. Use the dotted line on the template to cut two vellum pages and twenty ivory-laid paper pages to size.

25. Use the holes on the dotted template to punch holes through all the pages.

26. Decorate the front cover with outline corner stickers.

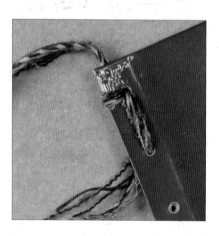

27. Gather the blue fibres and ribbons together, and wrap the ends with sticky tape to make a bodkin. Assemble the book by sandwiching the pages between vellum paper pieces, and then putting the covers on.

Tip

There is a helpful diagram on page 63 that shows the order in which to thread the cords.

28. Leaving a tail of 16cm (6¼in), take the yarn up through the second hole from the top, down through the top hole, then round the spine and down through the top hole again.

29. Bring the yarn up through the second hole from the top, take it round the spine, then back up through the same hole and down through the third hole from the top.

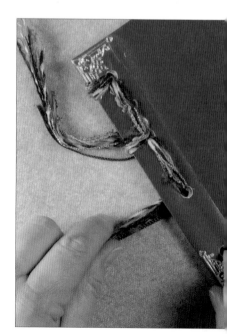

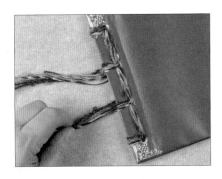

30. Take the yarn up through the bottommost hole, round the spine and up through the same hole. Take it down through the third hole from the top, round the spine and back down.

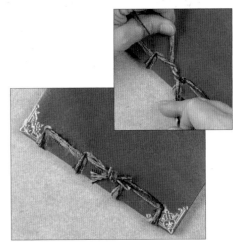

31. Use the tail and the remaining cord to tie a surgeon's knot on the back: take the cord under the tail twice and pull tight (see inset), then take the tail under the cord. Trim the excess.

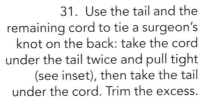

32. Push large jewelled brads through the front of each hole and secure. Hide the legs in the cord.

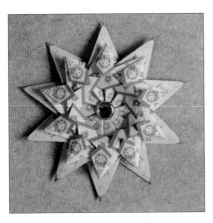

33. Cut the legs from a small jewelled brad and use a large glue dot to secure it to the centre of the rosette.

34. Use double-sided tape to secure the rosette in the centre of the book to finish the piece.

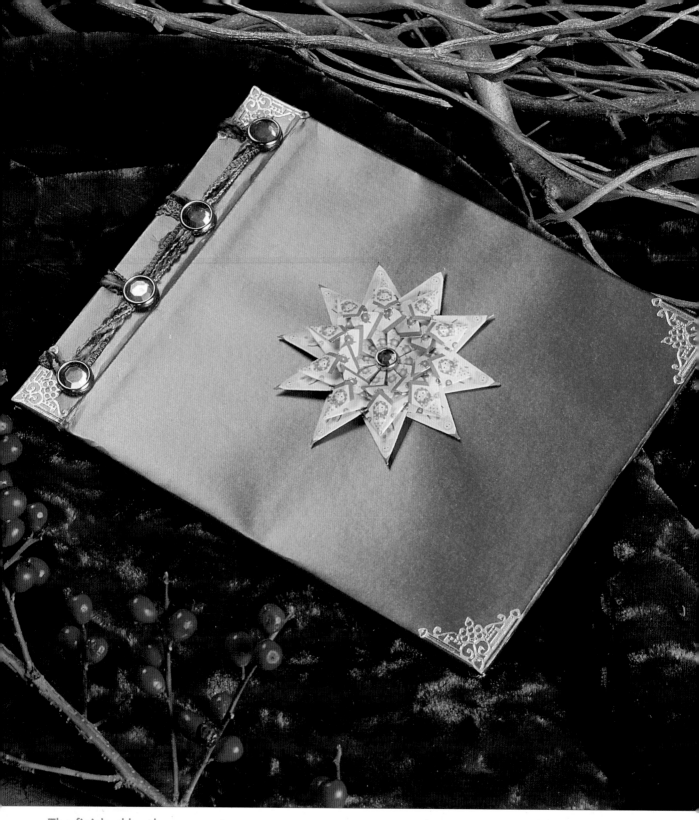

The finished book

The album could be used to create a family tree in photographic form, or a collection of prints that you treasure.

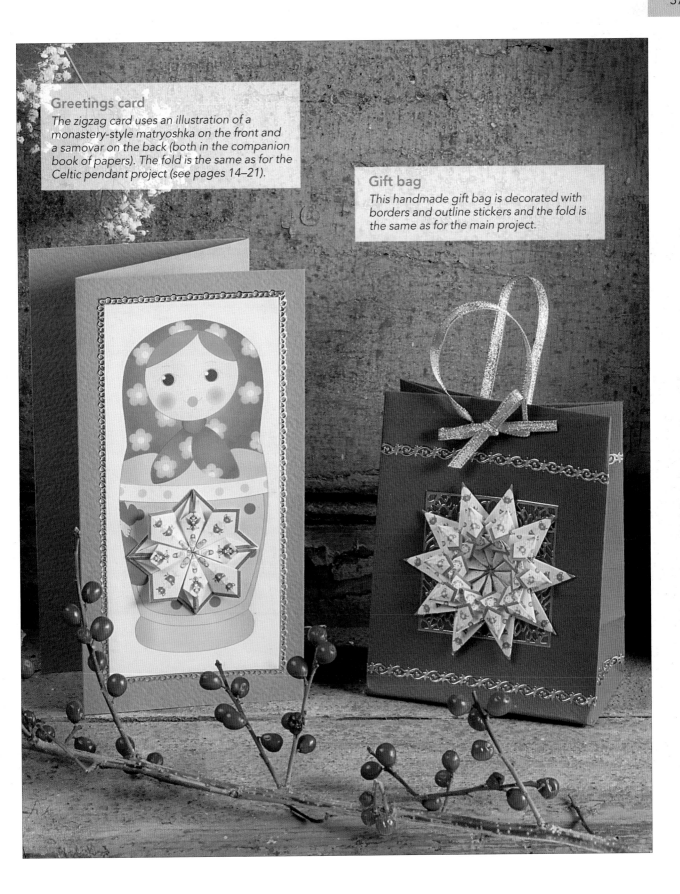

Greetings card

The zigzag card uses an illustration of a monastery-style matryoshka on the front and a samovar on the back (both in the companion book of papers). The fold is the same as for the Celtic pendant project (see pages 14–21).

Gift bag

This handmade gift bag is decorated with borders and outline stickers and the fold is the same as for the main project.

An Ancient Land

The reputed fabulous wealth of the Moguls and the amazing jewels worn by their women were the inspiration for the jewellery box project. India has had a continuous civilisation since 2500 BC, and when I think of India it is the Taj Mahal that immediately springs to mind. This breathtaking white marble monument of enduring love was built by Shah Jahan in memory of his beloved wife Mumtaz Mahal.

The rare white elephant was highly prized by Indian royalty. It was thought to have sacred powers and believed to be the mount of the war god. A white or light grey form of Asian elephant is regarded with special veneration in many areas of South-East Asia to this day and it became the inspiration for our paper architecture card on page 43.

The tea bag design depicts a pattern I saw embroidered on a friend's *salwar kameez*, a traditional dress worn by both women and men in South Asia.

You will need

- Cutting ruler and mat
- Scalpel
- Cocktail sticks
- PVA glue
- Ten 5 x 5cm (2 x 2in) and twenty-four 4 x 4cm (1½ x 1½in) tea bag papers
- Raw pine wooden chest 20 x 13 x 9.5cm (7¾ x 5 x 3¾in)
- Letraset Pro-Marker marker pen – Poppy
- Embossing gold foil
- 5mm (¼in) metallic gold tape
- Didi glue dots
- White pencil
- Starform outline sticker sheet – 1100 (gold)
- Paper stump
- Five 9mm (½in) red cabochons
- Six red and six green 5mm (¼in) cabochons
- Super-sticky tape 6mm (¼in) wide
- Paper Cellar craft jewel flowers – Complements flower shapes embellishment
- Scissors
- Tweezers

Folding diagram

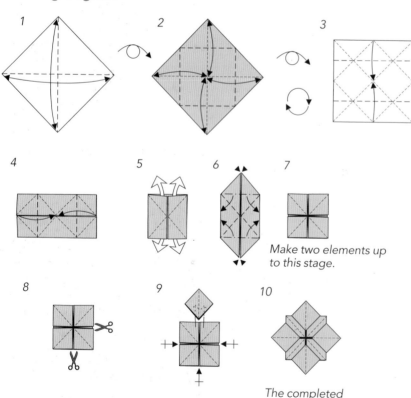

1

2

3

4

5

6

7

Make two elements up to this stage.

8

9

10

The completed motif, made up of two elements.

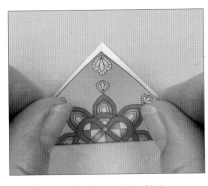

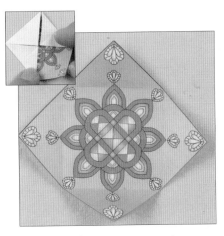

1. Place a 5 x 5cm (2 x 2in) tea bag paper face down. Fold it in half along the diagonal, then open it up, turn it through ninety degrees and fold it in half along the second diagonal. See diagram 1.

2. Open the paper up and turn it face-up. Fold each corner into the middle (see inset), then open it out. See diagram 2.

3. Turn the paper face-down, and fold the top and bottom edges down to the middle. See diagram 3.

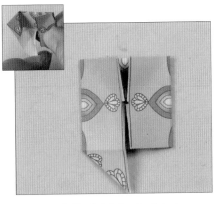

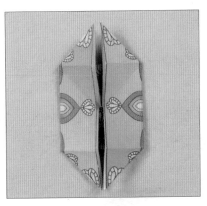

4. Fold the left side into the middle (see inset), then fold the right side into the middle. See diagram 4.

5. Carefully fold the inside lower left corner out (see inset), then flatten the paper. See diagram 5.

6. Fold the other corners out in the same way.

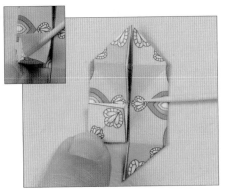

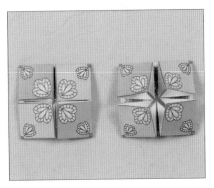

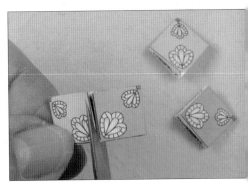

7. Use a cocktail stick to open a pocket at the lower left (see inset), then flatten it on the piece as shown. See diagram 6.

8. Repeat on the other corners, and make a second element in the same way. See diagram 7.

9. Cut one of the elements into four pieces using sharp scissors. See diagram 8.

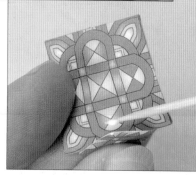

10. Slide one quarter into the side of the complete element (see diagram 9), making sure the top and bottom of the quarter overlap the complete piece (see inset). Use a cocktail stick to add a touch of PVA glue to the back to hold it in place.

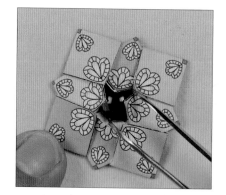

11. Repeat this process with the other three quarters (see diagram 10), then add a red craft jewel to the centre with tweezers. Secure it with a glue dot. This completes one motif. Make four more with 5 x 5cm (2 x 2in) tea bag papers and red craft jewels; six with 4 x 4cm (1½ x 1½in) tea bag papers and green craft jewels; and six with 4 x 4cm (1½ x 1½in) tea bag papers and red craft jewels.

13. Use a white pencil to mark a dashed guideline 0.5cm (¼in) in from the edge of the box. Work all round the box, then repeat on the other side.

14. Run 5mm gold tape along the white guidelines.

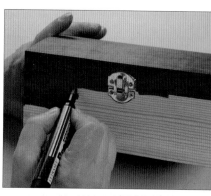

12. Use the red marker pen to colour the pine box. Work carefully across the whole surface, and allow each side to dry before moving on to the next.

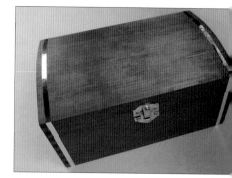

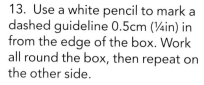

Tip

When you come to the hinges, trim the tape and use tweezers to pull the tape inside before continuing.

15. Place an outline sticker in the centre of the side.

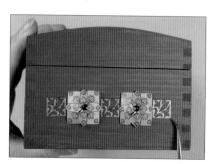

16. Attach a small motif on either side (one red, one green), and an outline sticker on the outside of each as shown.

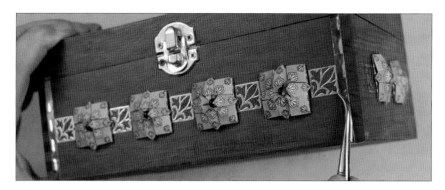

17. Repeat on the other sides, alternating the coloured jewels in the motifs.

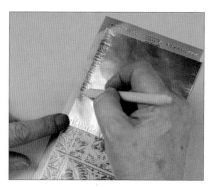

18. Place a 9.7 x 9.7cm (3¾ x 3¾in) piece of gold metal paper on top of the used outline sticker sheet. Rub a paper stump gently along each edge to transfer the design to the paper.

19. Find the centre of the gold paper and use double-sided tape to secure a large motif with a red jewel in the centre.

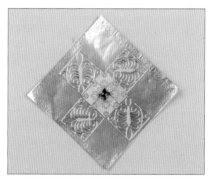

20. Secure a large outline sticker on each side, making sure that the directions of the designs follow in sequence as shown.

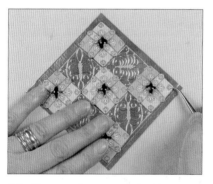

21. Secure the remaining large motifs on the corners using double-sided tape.

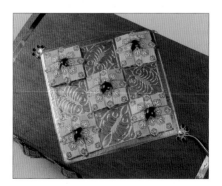

22. Secure the gold paper to the top of the box, and run outline sticker strips along each edge. Place craft jewel embellishments on both sides to finish.

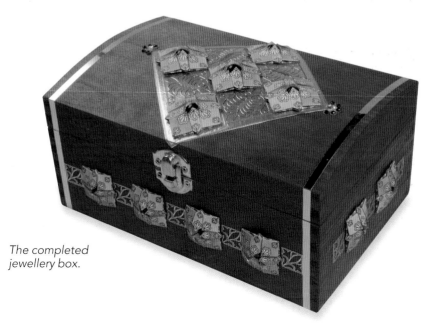

The completed jewellery box.

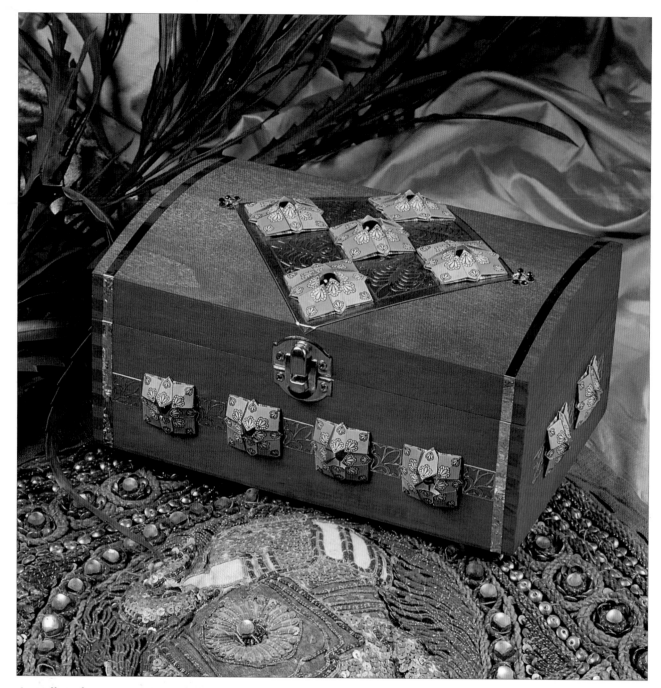

Jewellery box

Our box is lined with gold material. If you want to do this look on the Search Press website for the templates required. Cut these out of thin card and lay them on either a pad of paper tissues or wadding. Cut the material larger than the templates and tape the raw edges to the back of the templates. Fit the sides in first and then push in the bottom/top liner. A small gold tassel made from gold embroidery thread can be attached to the clasp.

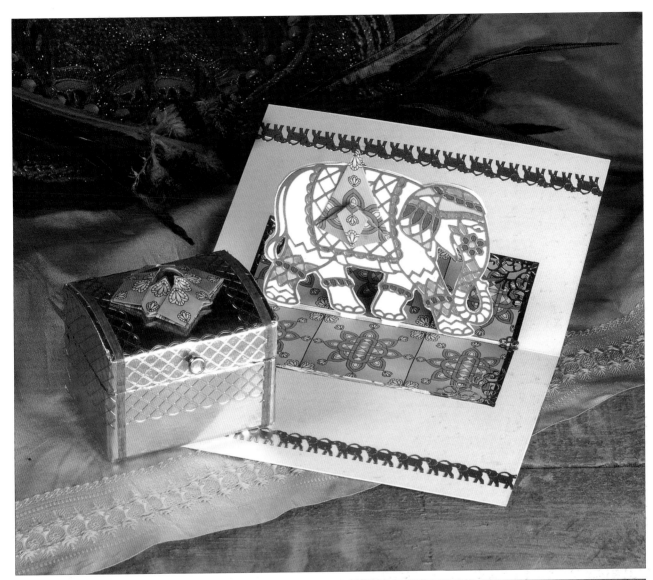

Gift box

The gold chest gift box was purchased in a hobby shop and we decorated it with border stickers, green flex-a-tape and a fold from the main project. A small eyelet was slid on to a jewelled brad and this serves as a small handle. The legs of the brad were slipped through a punched hole and opened out to secure it in place.

Greetings card

This paper architecture card depicts the sacred white elephant. Stick a pair of outline stickers on to the cut-out elephant and use glaze pens to colour areas within the design. The tea bag element uses the fold shown in the Lapland project (pages 54–59) and a further elephant graces the front cover of the card (see right). The pattern is available from the Search Press website.

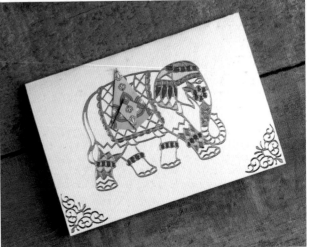

Home of Origami

Paperfolding originated in China in the first and second centuries AD and, together with the secret of papermaking, reached Japan in the sixth century. The Japanese named the folding technique origami – *ori*, meaning 'to fold', and *kami*, meaning 'paper' (and also 'God'). The latter becomes *gami* when combined with *ori*.

Tea bag folding is based on modular origami, where the same folded element is made a number of times and then either slid, stitched or stuck together. Kusudamas are made in this way and this project shows you how to make a simple one. In Japanese the name kusudama means medicine globe or herb globe, because aromatic herbs, spices and perfumes such as musk, cloves, etc. are placed in a small bag and then into the kusudama.

Originally from China these ornamental scented balls were introduced into Japan in the Heian era (AD 794 to 1192) and they can still be seen hung above beds in Japanese hospitals today. They are viewed as charms and bringers of good luck.

You will need

- Cutting ruler and mat
- Scalpel
- Scissors
- Ruler
- Twelve 8 x 8cm (3 x 3in) tea bag papers
- 3mm (1/8in) super-sticky double-sided tape
- 200cm (78¾in) blue kusudama cord
- Six 1.5cm (½in) diameter blue glass beads
- 5.7cm (1¼in) large-eyed beading needle
- Scoring tool

Folding diagram

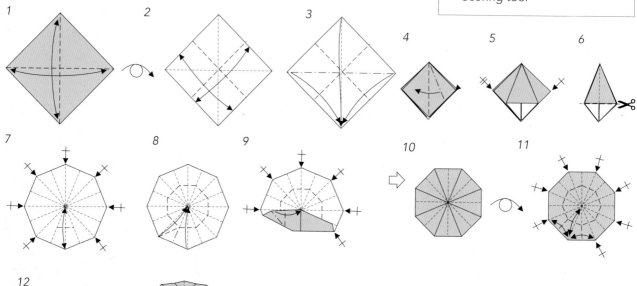

Make six elements up to this stage.

The completed kusudama made up of six elements.

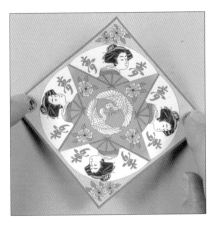

1. Place an 8 x 8cm (3 x 3in) tea bag paper face up. Fold it in half along the diagonal, then open it up, turn it through ninety degrees and fold it in half along the second diagonal. Open it up. See diagram 1.

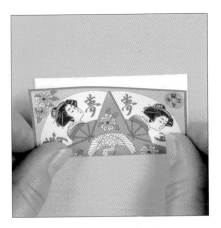

2. Turn the paper face-down then fold it in half down the middle as shown. See diagram 2.

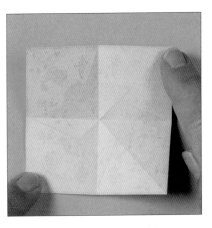

3. Open the paper up, then turn it ninety degrees clockwise and fold it down the middle again. Open it up.

4. Fold the sides up and in along the diagonal creases.

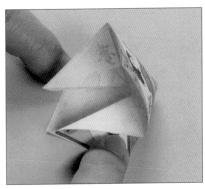

Tip

A perfect square makes a perfect fold, so take your time and cut out your squares carefully.

5. Continue folding in the sides along the creases until the paper lies flat. See diagram 3.

6. Fold the top layer on the upper right into the centre. See diagram 4.

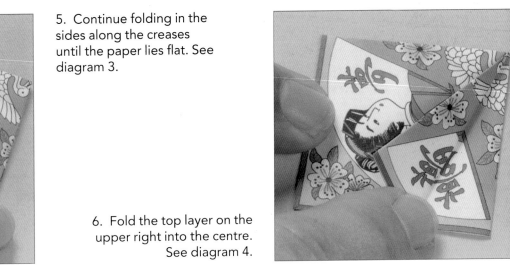

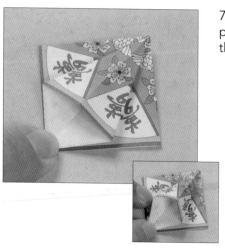

7. Use this crease to open a pocket (see inset), then flatten the pocket. See diagram 5.

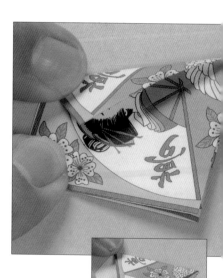

8. Turn the piece over and fold the left side into the centre. Make a pocket as before, and flatten it (see inset).

9. Take two layers over from the right side to the left side (see inset) until a flat picture appears as shown.

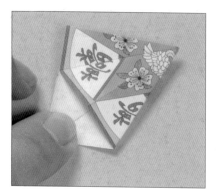

10. Make a pocket as before with the right side and flatten it.

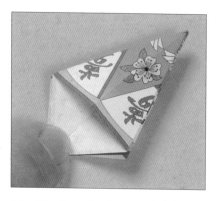

11. Finally, take the top left layer over to the right and make a flattened pocket with the piece this reveals. See diagram 5.

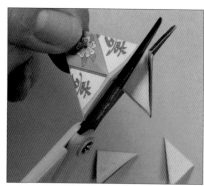

12. Trim the ends off with a pair of sharp scissors as shown. See diagram 6.

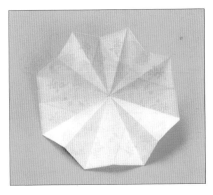

13. Open the piece up and place it face-down.

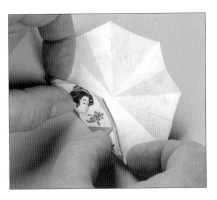

14. Fold one of the points of the shape into the centre and make a crease as shown.

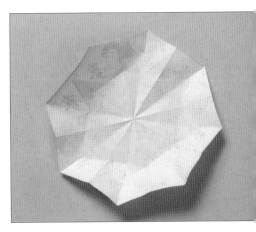

15. Repeat with all the points. This will make an octagon of creases in the centre. See diagram 7.

16. Fold a point into the centre and make a crease from the left-hand point of the octagon to the next point clockwise. See diagram 8.

17. Fold the second point into the centre along the crease. See diagram 9.

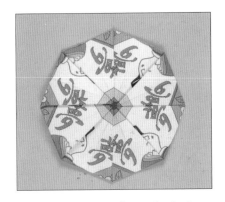

18. Continue working clockwise around the paper until all the points are in the centre. See diagram 10.

Note

The final point needs to slip under the first point as shown.

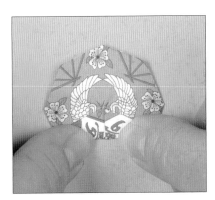

19. Turn the piece over and fold the lowest point into the centre. See diagram 11.

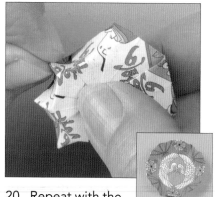

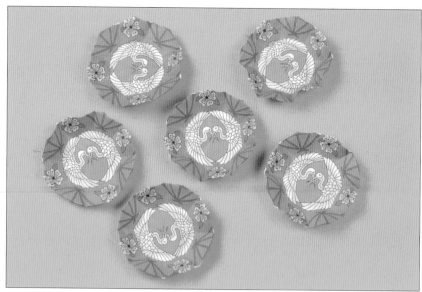

20. Repeat with the remaining points, then turn the paper over and pinch the areas between the points. See diagram 12. This will complete one element (see inset).

21. Make five more elements in the same way.

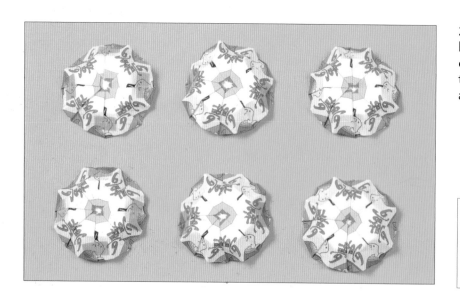

22. Put double-sided tape on the back of four sides of two of the elements, two sides of a further two, and leave two without tape as shown.

Tip
Glue dots can be substituted for the double-sided sticky tape.

23. Take an element with four pieces of tape and remove one piece of backing. Secure an element without tape as shown.

24. Attach the other element with four pieces of tape, then connect them with the other element without tape.

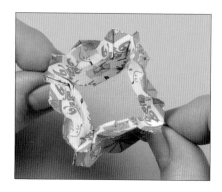

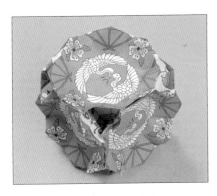

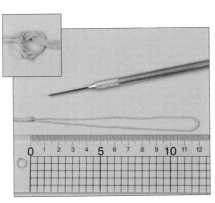

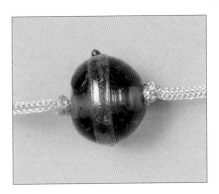

25. Remove the remaining backing from all the elements, and secure the two elements with two pieces of tape as the top and bottom. This completes one kusudama. Make a second in the same way.

26. Fold the kusudama cord in half and tie an overhand knot by taking the loop end over and through itself (see inset). Use the scoring tool to move the knot to 12cm (4¾in) from the loop end. Tighten it in place.

27. Thread the free ends through a large-eyed needle and thread a glass bead up to the knot. Secure it in place with a second knot underneath the bead.

Tip

If you can not find kusudama cord, you can use blue cotton embroidery thread instead.

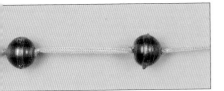

28. Leave 4cm (1½in) of cord, then secure another bead in place with two overhand knots.

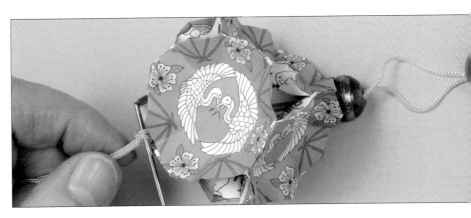

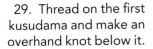

29. Thread on the first kusudama and make an overhand knot below it.

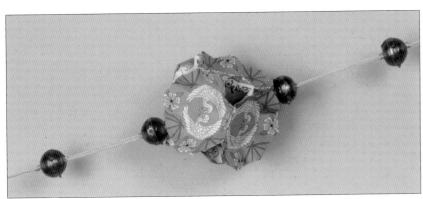

30. Thread on a bead and secure it with an overhand knot. Repeat once more so there are two beads beneath the kusudama.

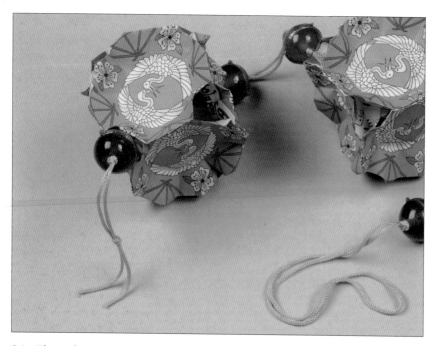

31. Thread on a second kusudama and secure a bead beneath it. Make an extra overhand knot 3cm (1⅛in) below the bead.

32. Fold a 12cm (4¾in) piece of card in half, make a small nick in both sides with a pair of scissors, and secure a 150cm (59in) piece of cord in the first nick.

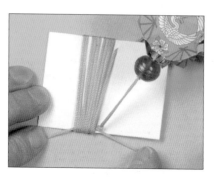

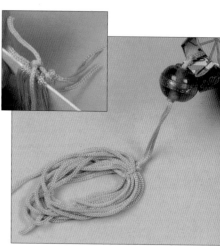

33. Wind the cord around the folded card ten times and secure the other end through the second nick.

34. Trim the excess and take one of the free ends of the cord on the main piece under the cords on the card.

35. Tie a double overhand knot using the free ends (see inset) and pull the card free carefully.

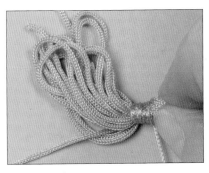

36. Make a loop with a 45cm (17¾in) length of cord. Hold the loop against the knot at the top of the tassel.

37. Begin to wrap the longer end of the new cord round the top of the tassel, working up towards the knot.

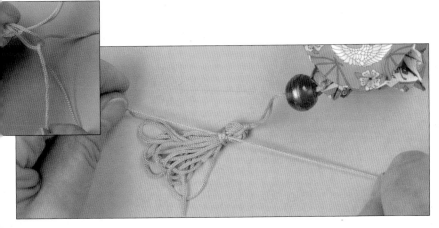

38. Keeping the cord taut, take it through the loop (see inset). Carefully pull the two ends of the new cord to tighten the loop, being careful not to lose the tension.

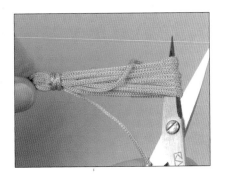

39. Trim the excess cord, then cut the loops of the tassel to finish.

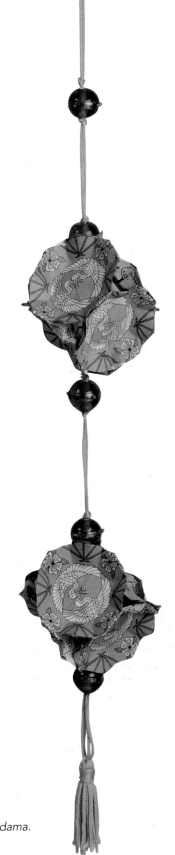

The finished kusudama.

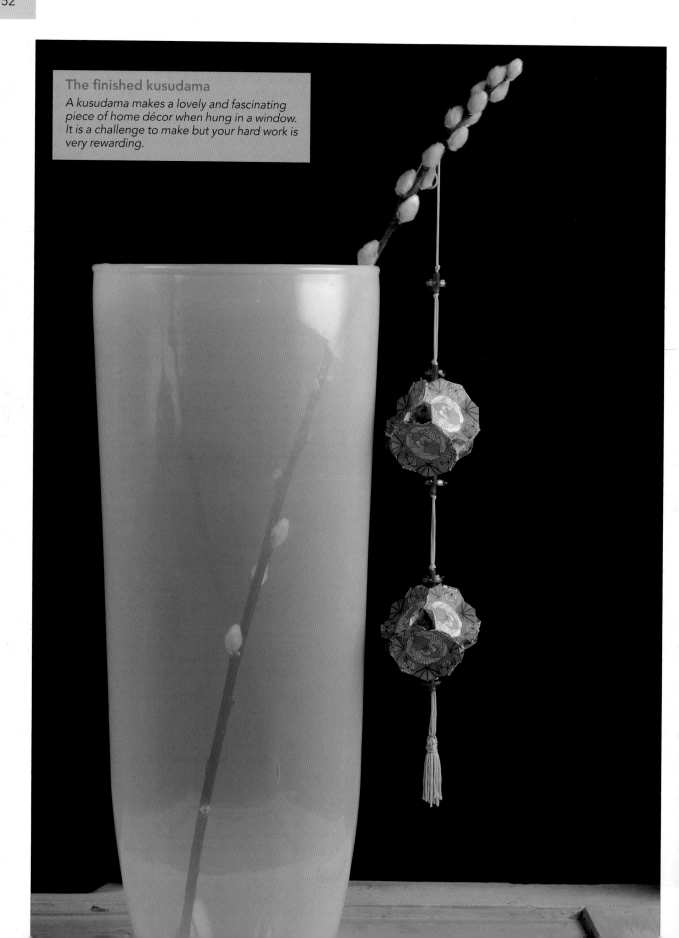

The finished kusudama

A kusudama makes a lovely and fascinating piece of home décor when hung in a window. It is a challenge to make but your hard work is very rewarding.

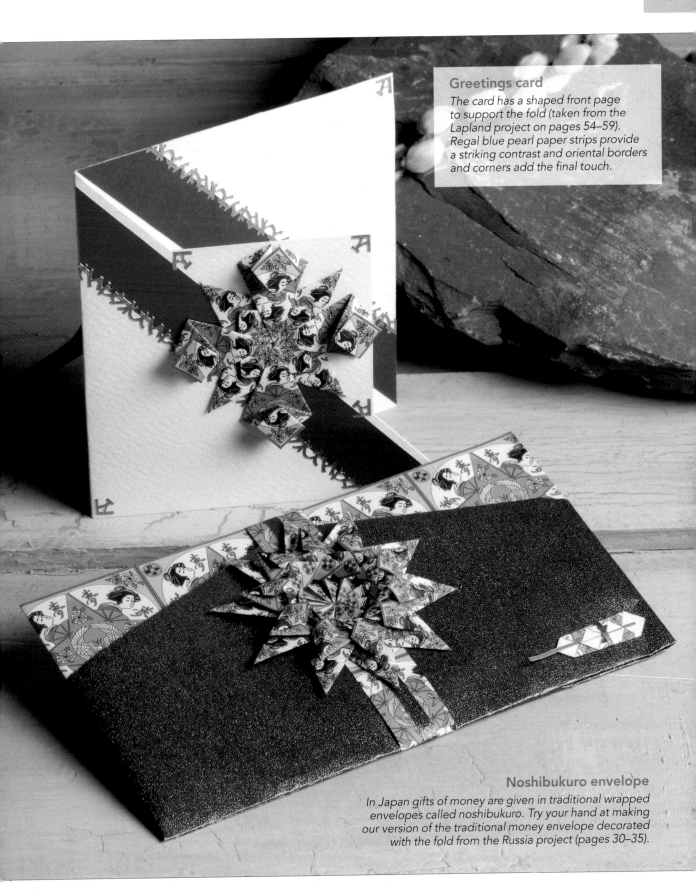

Greetings card

The card has a shaped front page to support the fold (taken from the Lapland project on pages 54–59). Regal blue pearl paper strips provide a striking contrast and oriental borders and corners add the final touch.

Noshibukuro envelope

In Japan gifts of money are given in traditional wrapped envelopes called noshibukuro. Try your hand at making our version of the traditional money envelope decorated with the fold from the Russia project (pages 30–35).

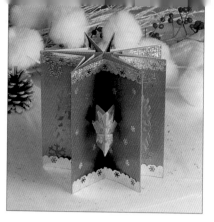

Land of the Midnight Sun

Each year many people travel to Lapland to see one of nature's wonders: the Northern Lights, more properly called the aurora borealis. This phenomenon usually takes the form of an arch with its apex towards the magnetic pole (the North Pole in this case) followed by arcs, bands or curtains usually green in colour but often seen in shades of blue and red and occasionally yellow or white.

A very famous and well-loved gentleman is also reputed to live here along with his reindeer. Each December, children of all ages make their way to Lapland to pay him a visit and maybe – just maybe – have a ride on a sleigh pulled by reindeer.

You will need

- Cutting ruler and mat
- Scalpel
- Cocktail sticks
- PVA glue
- Twenty 4 x 4cm (1½ x 1½in) and two 5 x 5cm (2 x 2in) tea bag papers
- One A4 sheet of pine green pearl card and three A4 sheets of emerald card
- Three A4 sheets of pine green holographic paper
- Three A4 sheets of silver holographic paper
- One A4 sheet of silver paper
- 1m (39½in) of 7mm (¼in) wide silver ribbon
- Small glue dots
- Double-sided sticky tape: 12mm (½in) wide and 3mm (⅛in) wide
- Paper Cellar snowflake stickers – Complements blue and silver
- Starform outline sticker sheets – 8504 (silver snowflakes); 7055 (transparent glitter snowflakes)
- Line outline transparent glitter sticker 1004
- Snowflake border punch

Folding diagram

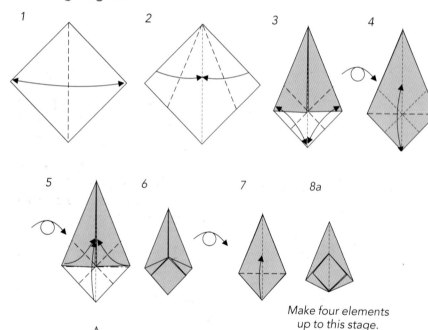

Make four elements up to this stage.

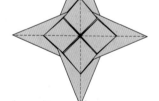

Combine the elements to match the diagram.

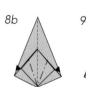

Make four more elements up to this stage.

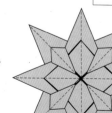

The completed rosette.

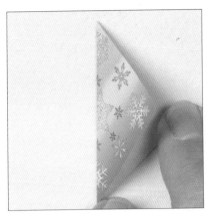

1. Place a 4 x 4cm (1½ x 1½in) tea bag paper face-down and fold it in half along the diagonal. See diagram 1.

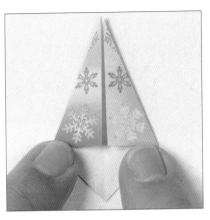

2. Open it up, then fold the sides into the crease. See diagram 2.

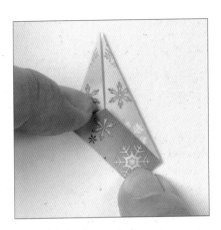

3. Fold the lower left part over to the right as shown.

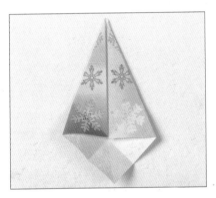

4. Take the lower left part back, and repeat with the lower right part to make the creases shown. See diagram 3.

5. Turn the piece over and fold the lower part up. See diagram 4.

6. Fold the lower part back down, turn the paper over, and fold the sides in as shown to make a square. See diagrams 5 and 6.

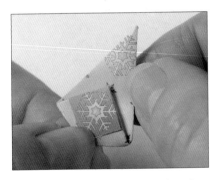

7. Turn the paper over and make a fold between the two widest points of the paper so the square comes over to the back. See diagram 7.

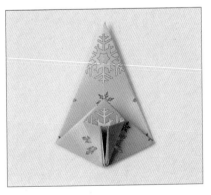

8. Fold the lower sides of the square in as shown to make creases on both sides. See step 8a.

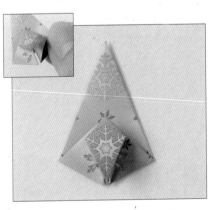

9. Fold the lower sides back, then push the sides in along the creases (see inset) to complete an element. See step 9.

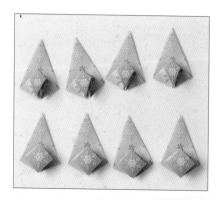

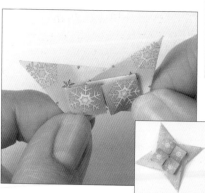

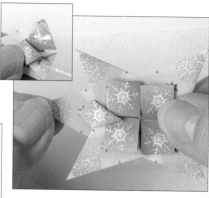

10. Make three more elements in the same way (top row) and four more up to the end of step 8a (bottom row).

11. Use a dab of PVA to glue two of the bottom row elements together as shown in the main picture, then use glue to attach the other two elements in the same way (see inset).

12. Use a cocktail stick to apply PVA glue to one of the top row elements (see inset), then slot it into the rosette.

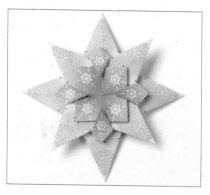

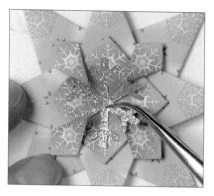

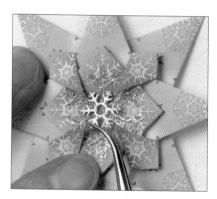

13. Glue the other three elements in place to complete the rosette.

14. Carefully slip a snowflake sticker inside the rosette.

15. Place a smaller sticker on top of the larger one.

16. Fold a sheet of A4 green card in half, then fold the short sides back in towards the fold to make a concertina.

17. Use a craft knife and cutting mat to trim 6.5cm (2½in) from the top of the concertina.

18. Use strips of 12mm (½in) double-sided tape to secure the middle of the card together to make a booklet.

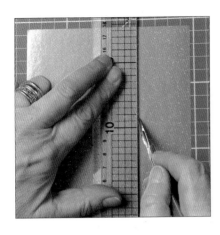

19. Cut two 13 x 14.5cm (5 x 5¾in) pieces of pine green holographic paper as per the template (see page 63). Fold each in half and cut the slits shown on the pattern with a craft knife and cutting mat.

20. Cut a 2 x 30cm (¾ x 12in) strip of holographic silver paper. With the back of the border punch uppermost, line up the paper with the design as shown. With the punch the right way up and laid on a firm surface, punch a decoration into the strip.

21. Move the strip up and align the punched decoration with the pattern on the punch (see inset). Punch the pattern, then repeat until the whole strip has been punched.

22. Cut two 11cm (4¼in) strips from the long strip, making sure you cut between the snowflake holes, not through them. Fold each strip in half.

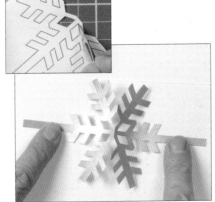

23. Fold an A5 piece of silver paper in half and use low-tack tape to secure the snowflake template to the paper, making sure the middle is on the fold.

24. Starting with the areas nearer the fold (see inset), carefully cut the snowflake out.

25. Cut out a pop-up base in the same way.

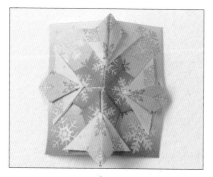

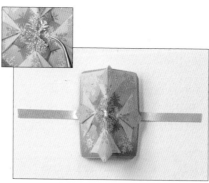

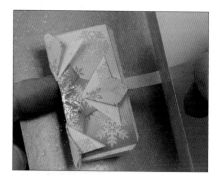

26. Following steps 1–13 from the Andalucia project (see pages 24–26), make a rosette, using four 4 x 4cm (1½ x 1½in) and one 5 x 5cm (2 x 2in) Lapland tea bag papers.

27. Place a snowflake sticker in the centre of the rosette, then secure it to the pop-up base with 12mm (½in) double-sided tape.

28. Carefully slide the legs of the pop-up base through the slots of the prepared pine green holographic paper.

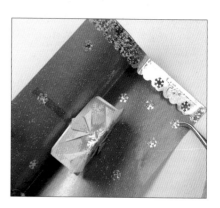

29. Close the paper, fold the leg over and secure it on the back with sticky tape. Repeat with the other leg, making sure the piece pops up before you secure it.

30. Stick 3mm (⅛in) double-sided tape to the ends of the punched silver borders (see inset), then remove the backing and carefully attach the strips to the inside of the pine green holographic paper.

31. Use the spare punched snowflakes from step 21 to decorate the page. Attach them with small glue dots. This completes the first page.

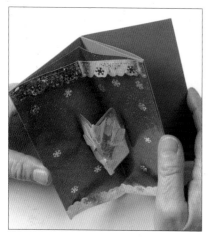

32. Run 12mm (½in) double-sided tape up the long edges of the first section of the concertina and secure the page inside.

33. Use the snowflake piece to make a second page, decorating it with snowflake stickers and outline stickers instead of the punched snowflakes. Secure the page to the second concertina section with 12mm (½in) double-sided tape. This completes the first unit. Make a second in the same way.

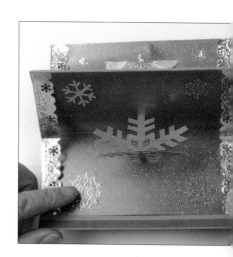

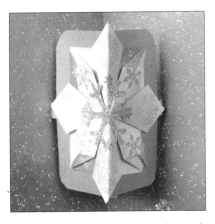

34. Make a rosette using the Irish tea bag fold (steps 1–18 on pages 15–17) with four 4 x 4cm (1½ x 1½in) Lapland papers. Mount this on a pop-up base, and mount it on a prepared page of pine green holographic paper.

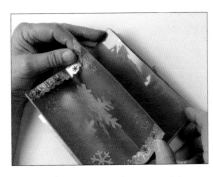

35. Make a second page with a snowflake pop-up, decorate it like the other pages, and use it with the Irish tea bag folded page to make a third unit. Secure the three units together into a book using strips of 12mm (½in) double-sided tape, making sure the sequence alternates between snowflake and tea bag folded pop-up.

36. Close the book and use 3mm (⅛in) double-sided tape to secure 32cm (12½in) lengths of silver ribbon to the front and back of the book, using the template (see page 63) as a guide.

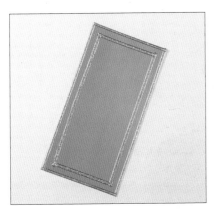

37. Cut a 7.5 x 14.5cm (3 x 5¾in) piece of green pearl card and decorate it with glitter outline sticker strips and stars as shown.

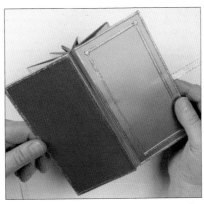

38. Make a back cover in the same way, but only run the outline strips round the edges. Secure both of the covers to the book with 12mm (½in) double-sided tape.

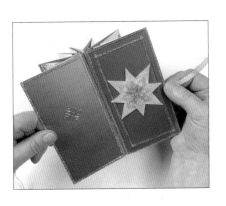

39. Secure the rosette you made earlier to the front cover with 12mm (½in) double-sided tape, and finish the book by applying an outline sticker to the back cover.

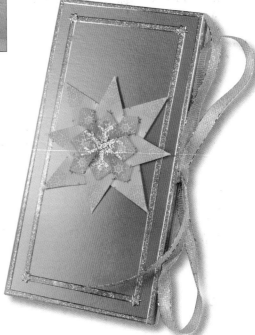

The finished book.

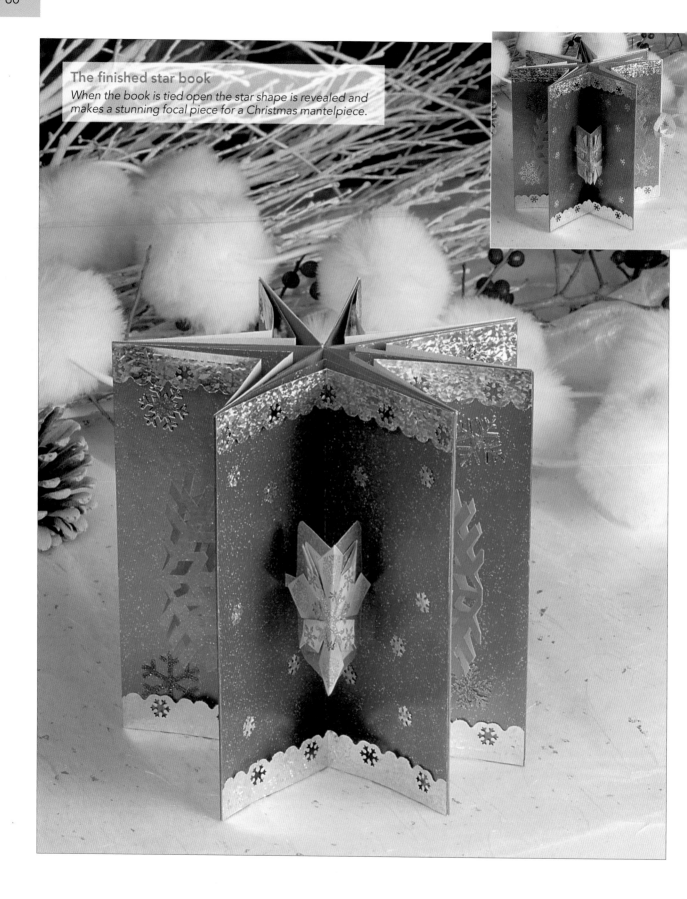

The finished star book

When the book is tied open the star shape is revealed and makes a stunning focal piece for a Christmas mantelpiece.

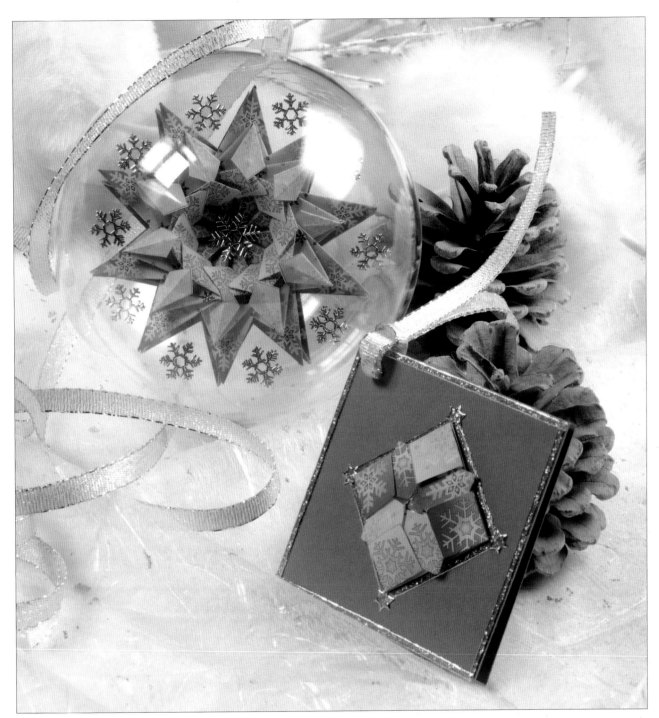

Bauble

Using the Lapland papers, make two copies of the fold from the Russian project (see pages 30–35) and stick them to each side of a large bauble divider. Add outline sticker snowflakes to each side and encase the piece in a correctly-sized globe to create a magical decoration.

Gift tag

This gift tag displays the fold from the jewellery box project (see pages 38–41) on the front. Add transparent glitter line stickers and some tiny snowflakes for a classy look.

Templates

The templates on the following pages are reproduced at half of the actual size. You will need to photocopy them at 200 per cent for the correct size.

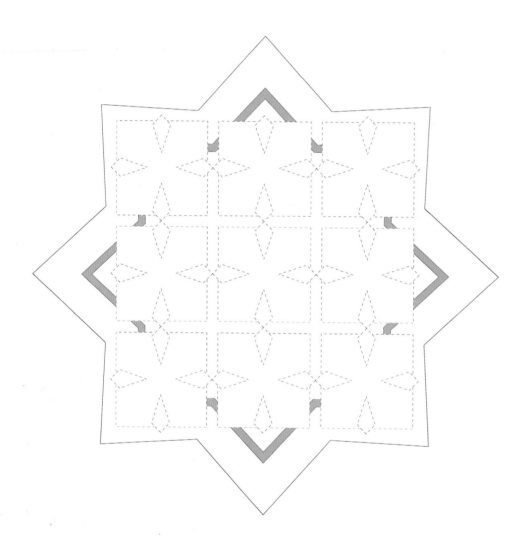

Template for the Andalucia project. Cut out the grey areas and then along the outer (solid) cutting line. The dotted lines show where the completed rosettes should be placed.

Templates for the Russia project.

Front and
back covers

Start

Finish

1

2

3

4

The dotted lines indicate
the size for the pages.

Solid lines and black arrows indicate where to take the
threads over the spine, while dotted lines and white arrows
indicate where to take the threads under the spine.

Templates for the Lapland project.

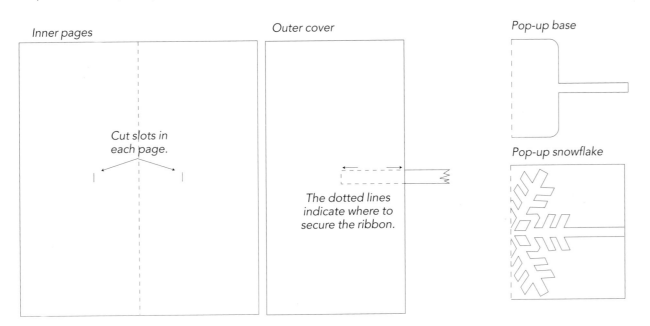

Inner pages

Outer cover

Pop-up base

Cut slots in
each page.

The dotted lines
indicate where to
secure the ribbon.

Pop-up snowflake

Index

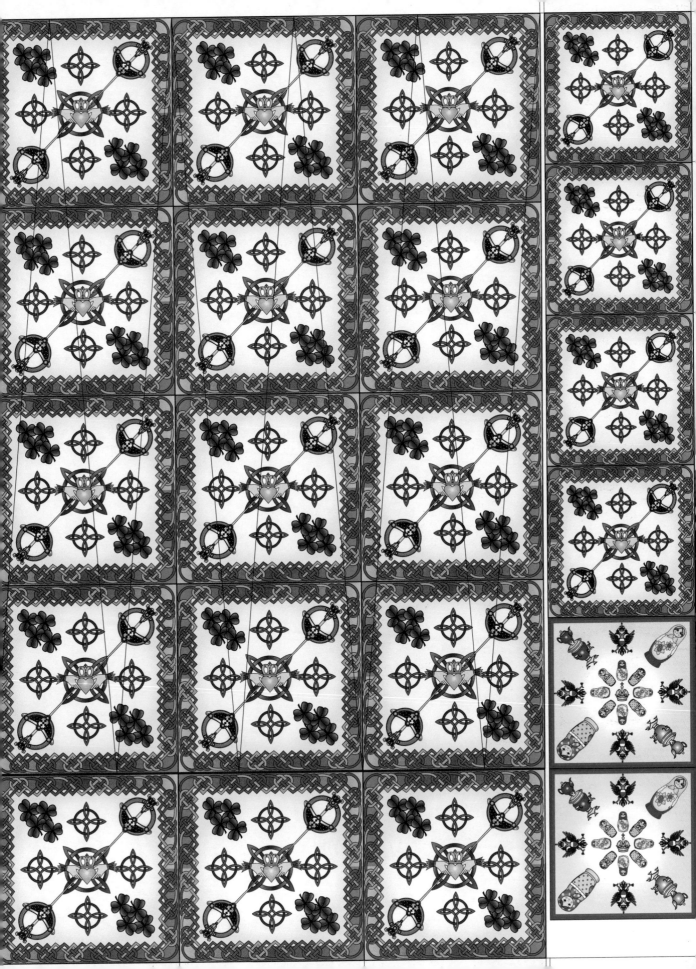

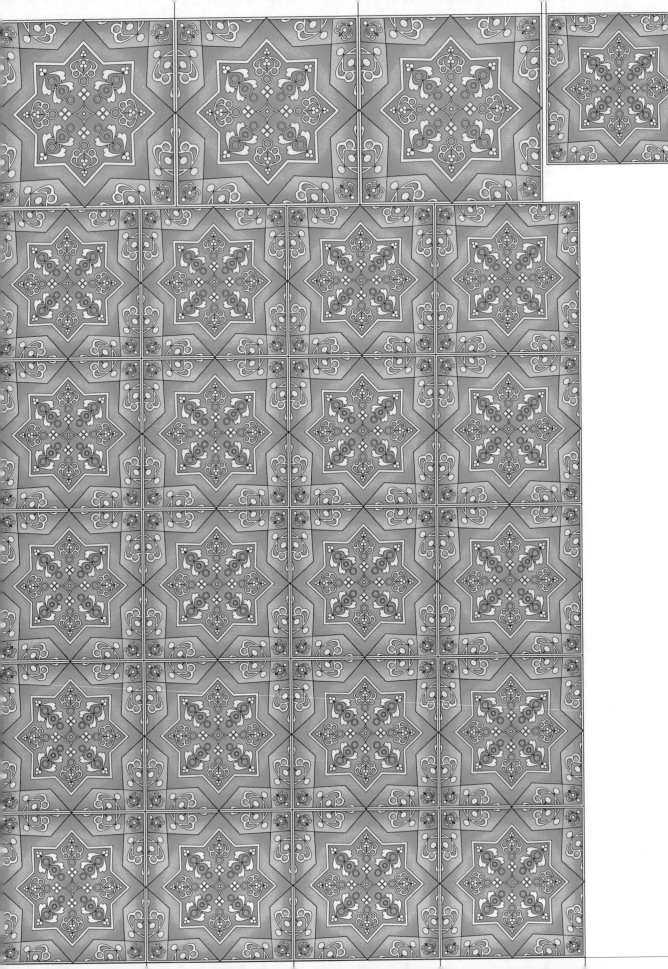

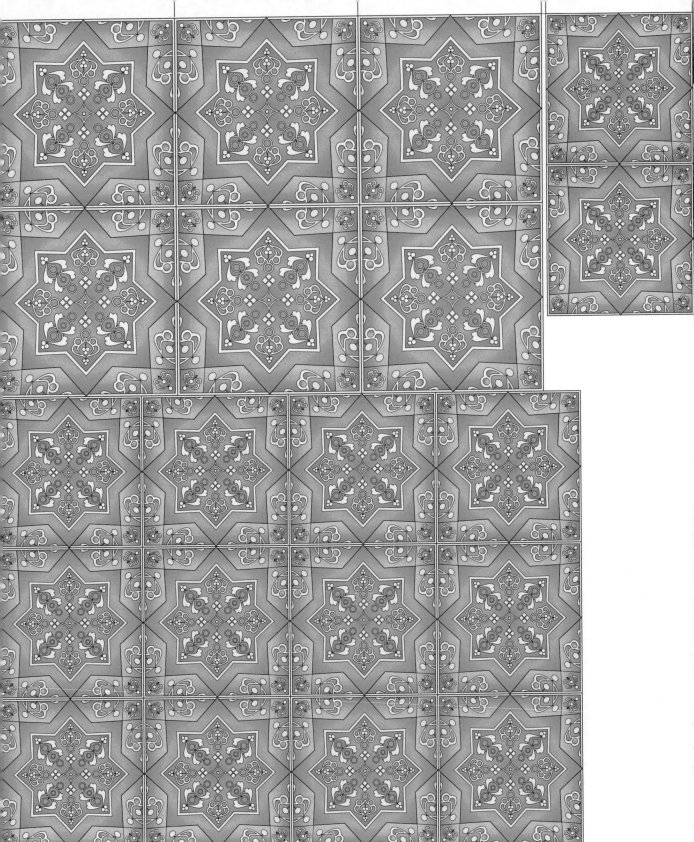

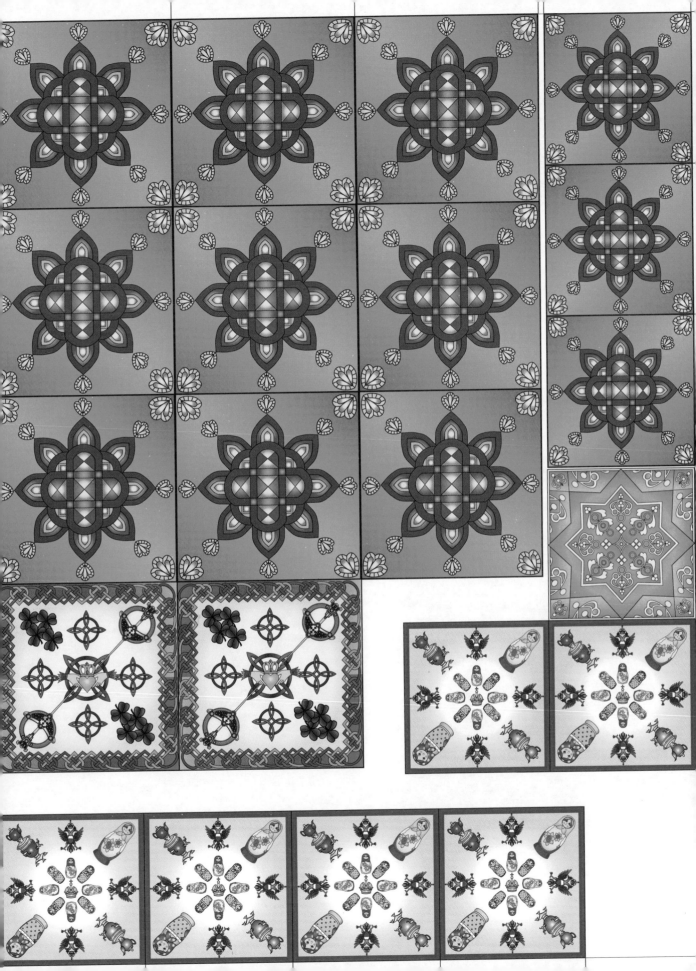

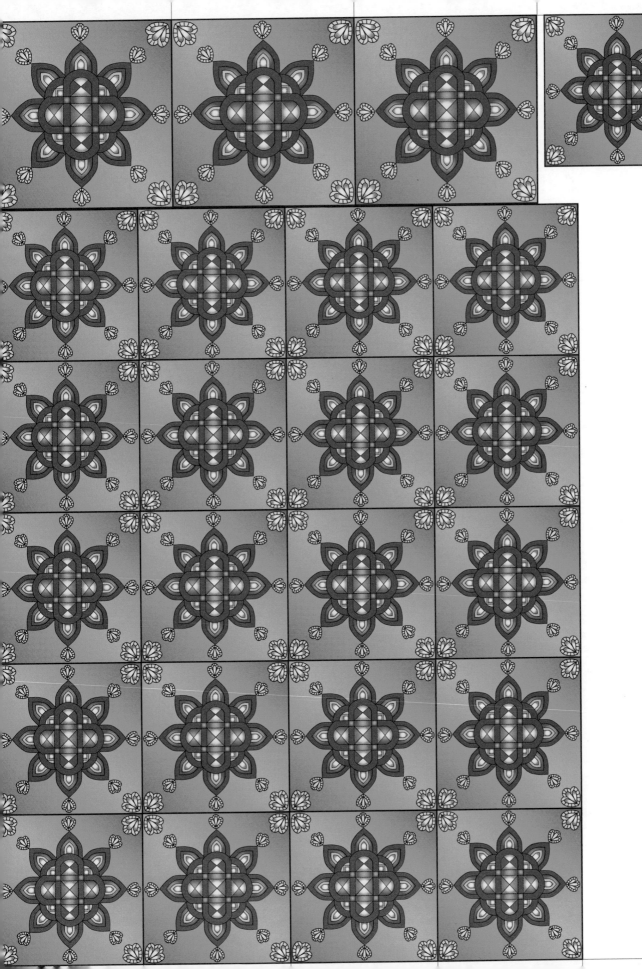

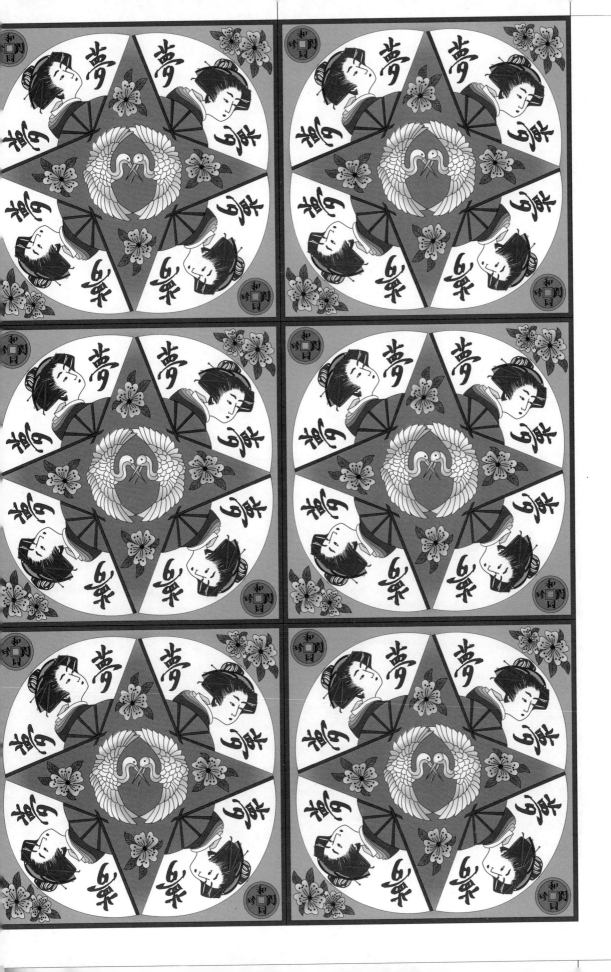

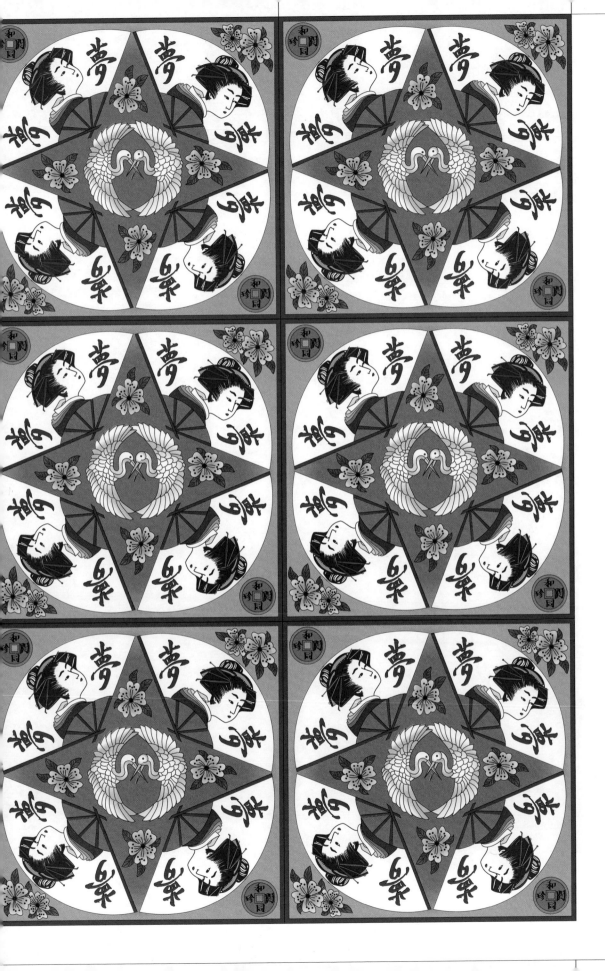